Selections from
The Irvine Museum

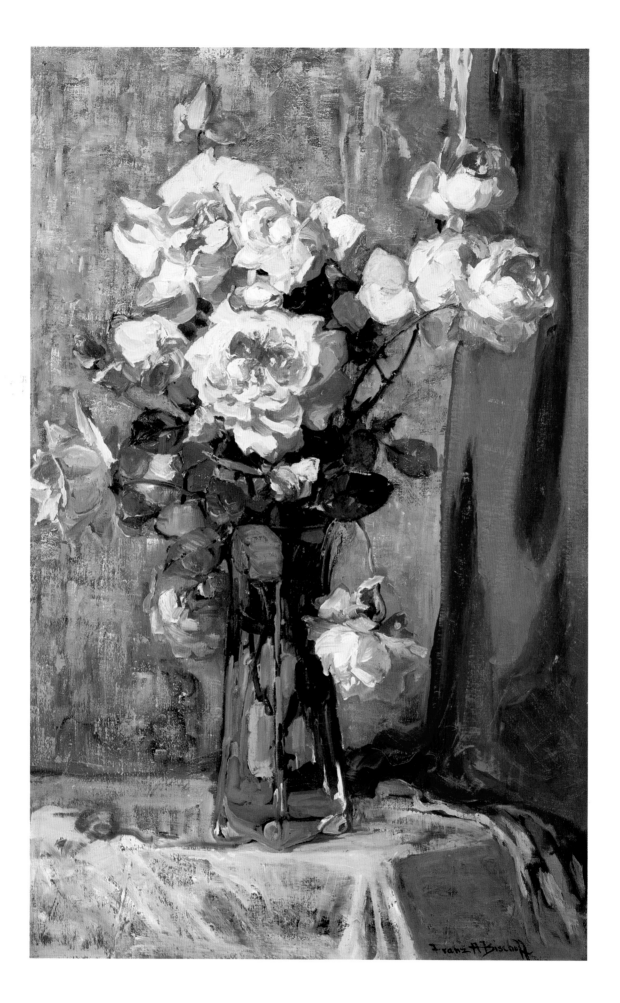

Franz A Bischoff

Selections from

The Irvine Museum

WITHDRAWN

JEAN STERN
Excutive Director, The Irvine Museum

JANET BLAKE DOMINIK
Curator, The Irvine Museum

HARVEY L. JONES
Senior Curator, The Oakland Museum

THE IRVINE MUSEUM

This book was published in conjunction with the exhibition Selections from The Irvine Museum.

Exhibition Itinerary

THE FLEISCHER MUSEUM
Scottsdale, Arizona
1 March 1993 - 31 May 1993

THE IRVINE MUSEUM
Irvine, California
10 July 1993 - 11 September 1993

THE OAKLAND MUSEUM
Oakland, California
13 November 1993 - 20 February 1994

ISBN 0-9635468-0-5 (Hardcover)
ISBN 0-9635468-1-3 (Softcover)

Copyright ©1992 by The Irvine Museum, Twelfth Floor,
18881 Von Karman Avenue, Irvine, California 92715

First edition. First printing.
Library of Congress Catalog Card Number 92-075559

Design and typography: Dana Levy, Perpetua Press
Photography: Casey Brown
Color separations and printing: Paragon Press
Binding: Stauffer Edition Bindery

COVER:
GRANVILLE REDMOND (1871-1935)
California landscape with flowers, n.d.(detail)
Oil on canvas
32 x 80 inches
(see page 34)

FRONTISPIECE:
FRANZ BISCHOFF
Roses, c. 1912
Oil on canvas
32 x 20 inches

Contents

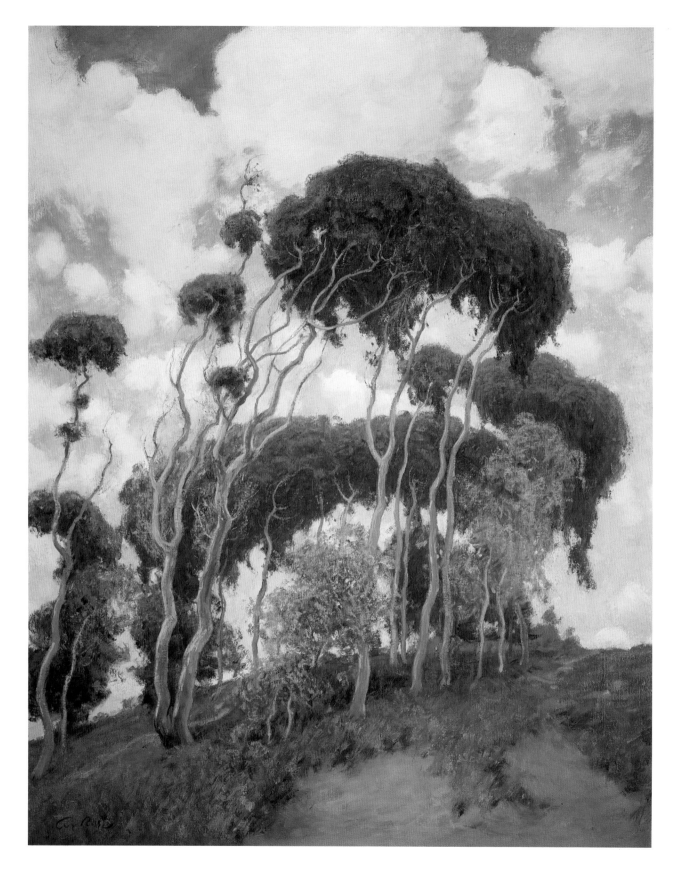

GUY ROSE
Laguna Eucalyptus, c. 1916
Oil on canvas
40 x 30 inches

Introduction

I T IS WITH GREAT PRIDE AND PLEASURE that we present this selection of California paintings from the holdings of The Irvine Museum.

The Irvine Museum was founded in 1992. Much of what you will see in this book highlights the principal reasons that led to the founding of the museum. Paramount is the conviction that the paintings housed in our museum are significant and indicative of the highest standards of American art. Furthermore, their beauty is magnificent and people everywhere will have their lives enriched by viewing them.

Secondly, I feel very strongly that the history and annals of California need to be documented, preserved, and taught to our heirs. The best way to understand the past is to have lived through it, and this art is an outstanding way to experience the exhilaration and vitality of this meaningful time in our history.

Finally, I was born and raised in California and spent a great deal of time outdoors. I grew up with a strong love and respect for nature and its inextricable bond to the human spirit. The environment is part of our essence, and it can never be removed from our lives. Of late, and hopefully not too late, we have learned of its fragile and impermanent structure. We abuse it at our peril.

Thus, the multiple aspects of California Impressionist paintings, with their beauty, their significance as artworks and historical records, and their reverence for nature, have made a deep and abiding impact on me. They stand in silent testament to our regard for the environment, and their elegant account must not go unheeded. I sincerely hope that all who see these firsthand will be as moved by them as I have been.

JOAN IRVINE SMITH
President

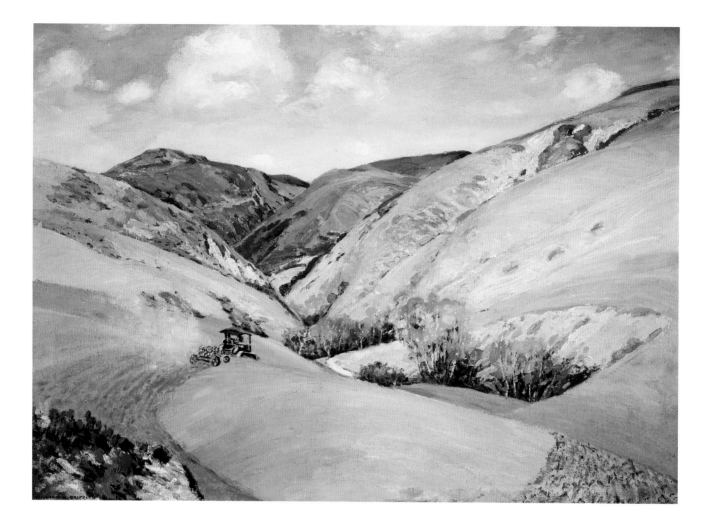

WILLIAM GRIFFITH
Harvesting Beans, Irvine Ranch, 1931
Oil on canvas
30 x 40 inches

*The Irvine Ranch was noted for the
cultivation of lima beans which were
harvested and processed on the ranch.
Today the original bean processing plant
on Sand Canyon Avenue has been
designated an historical landmark.*

Acknowledgments

THE CREATION AND PLANNING of an exhibition and book requires the talents and support of numerous people. The Irvine Museum is indebted to Janet Blake Dominik and Harvey L. Jones, whose essays, combined with one that I wrote, make up the text of this book. All three of us have specialized in the art of California for most of our professional careers. Janet, who holds the position of curator in our museum, has been responsible for some of the most significant current scholarship in this field. Over the years, it has been my privilege and pleasure to work with her on several art historical projects. Harvey Jones has been instrumental in asserting The Oakland Museum's lead in research and exhibition of California art. An energetic writer and lecturer, he is a recognized authority in our discipline.

Furthermore, we are grateful to the museums that will present this exhibition to their constituents and patrons. The Fleischer Museum and its director, Donna H. Fleischer, have been a steadfast source of support and encouragement. My relationship with Mort and Donna Fleischer has spanned over a decade, and my personal and professional admiration for them has continually grown. Likewise, The Oakland Museum has earned its enviable position by strenuously championing the art of California. The newly formed Irvine Museum is honored in having Oakland as a venue for its first travelling show.

Developing this exhibition and book required specialized help. James I. Swinden proved invaluable in his role as financial administrator. Pam Ludwig catalogued and classified a large number of paintings from which the final selection was made. All photographs of paintings reproduced herein are by Casey Brown. The elegant style of this book is the work of our graphic designer, Dana Levy of Perpetua Press. Janet Dominik, one of the aforementioned essayists, also acted as production coordinator, seeing that a myriad of particulars was performed.

None of this could have happened without the commitment and perseverance of two very special people: Joan Irvine Smith and her mother, Athalie R. Clarke. Their unswerving confidence and motivation has lovingly inspired the development of The Irvine Museum from its conception to the dynamic reality of today and, indeed, to its future potential. It was Joan Irvine Smith's vision and dedication that initiated our museum. Her guidance and support has allowed all the above-named individuals to exercise their talents and special gifts to produce this volume.

JEAN STERN
Executive Director

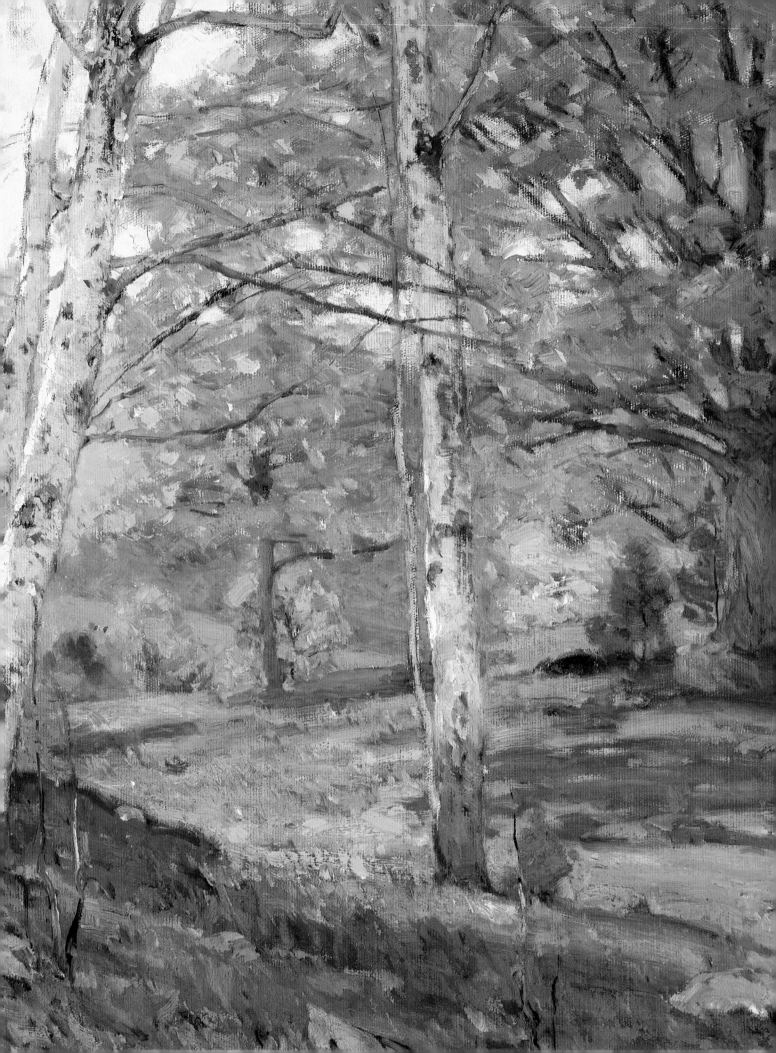

American Impressionism: A Stylistic Perspective

By Jean Stern

IN THE EARLY YEARS of the twentieth century, California produced a unique artistic style which combined several distinctive aspects of American and European art. This style, which is often called California Impressionism or California Plein Air painting, after the French term for "in the open air," concerned itself with light and color. As a variant of the American Impressionist style, it focused directly on the abundant California light.

All visual experiences begin with light. The intent of representational art is to render physical objects, and that, in turn, is solely the portrayal of the effects of light on those objects. Color is the way light is either reflected or absorbed by an object. The land became the principal subject of this style, and it was represented as clean and unspoiled, with strength and grandeur. The sun shone its light on the land and gave it color: greens of spring, browns of late summer and fall, and everywhere, the deep blue mantle of the sky.

Born in France among a small group of alienated artists in the late 1860s, and proclaimed in Paris in a momentous exhibition in 1874, Impressionism is perhaps the culmination of the development of visually representational art in western culture. Art is culturally defined and progresses in developmental stages. Each generation reinvents the modalities of style, but this does not happen in an intellectual vacuum. The new style owes some debt to the predecessor. Impressionism sprang from the tenets of European Realism of the mid-nineteenth century, a movement which itself rebelled from the style of the French Academy, a manner which was perceived as banal and artificial.'

Realism's purpose was to give a truthful, objective, and impartial representation of the real world based on meticulous observation of contemporary life. As practiced by Gustave Courbet (1819–1877) and Jean François Millet (1814–

WILLIAM WENDT,
Sycamores and Oaks (detail)

11

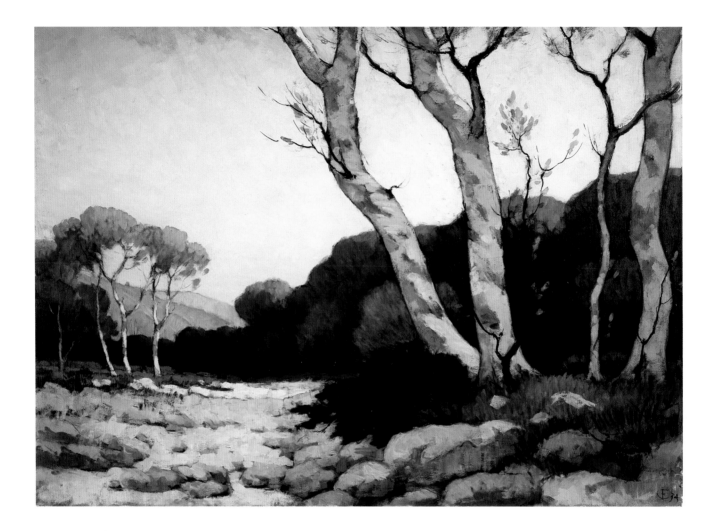

FRANK TOLLES CHAMBERLIN
Eaton Canyon, 1934
Oil on canvas
26 x 36 inches

Frank Tolles Chamberlin believed in the simple, classical approach to his art. This well-balanced composition is based on careful considerations of the relationship of dark and light, as well as a simplified approach to form.

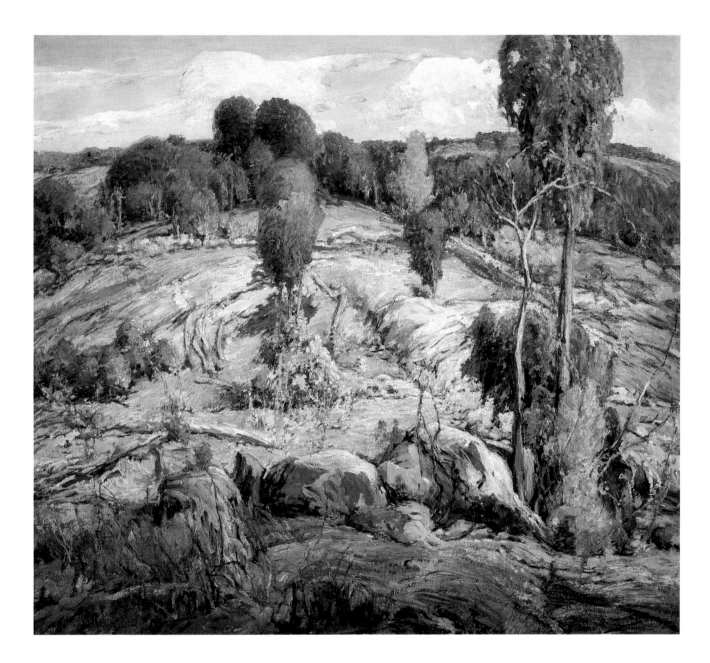

CHARLES REIFFEL
Summer, n.d.
Oil on canvas
34 x 37 inches

"A painter of hills is Mr. Reiffel, the thing that he delights in is the interweaving of line with line, the rise and fall of the linear rhythm. . . . Mr. Reiffel is direct, candid, clear. . . . entirely in sympathy with the modern tendency toward pure color and bright light." —Leonard Alson Cline, Detroit News, *c. 1910.*

1875), it was first and foremost concerned with nature and dealt with life in the rustic settings of France. Coming at the height of the consequences of the Industrial Revolution, with its attendant mass urbanization, environmental pollution, and social transformations, Realism harkened to the idyllic life of the immediate past, to a time, real or imagined, when people were in harmony with nature and its bounty. It was a movement to democratize art, in step with other mid-century demands for social and political democracy. Declaring that art must have relevance to contemporary society, the Realists refused to paint moralistic or heroic models from the past and, instead, directed their thoughts to themes that acclaimed people and events in more commonplace circumstances and in their own time. In that vein, Millet, who painted the daily life of the French farmer, promoted an idealistic and romantic ideal emphasizing the dignity of peasant life. Millet was one of a group of Romantic-Realist painters who imbued their works with a dramatic sense of light, most often energizing their compositions with vivid end-of-the-day sky effects. These artists lived and painted in the village of Barbizon, thus giving name to this aspect of Realism, a romantic model of people and nature, coupled with dramatic lighting. The Barbizon style found a quick and willing group of followers in late nineteenth century Europe and America.

The concerns of artistic methodology and preference of subject matter caused the Impressionists to part company with the Realists. Technically speaking, the Realism of Courbet and the Romantic-Realism of Millet were nonetheless academic approaches, differing only in subject matter and objective content. Like its predecessor, Impressionism repudiated most of the tenets of the academy. The time-consuming, over-worked method of painting, which required days or weeks to produce a painting, was spurned by the Impressionists. They lamented the lack of natural light and color which often characterized an academic canvas, a consequence of painting in the studio from preparatory sketches, preferring instead to paint directly on primed canvas and to set the easel out of doors. Philosophically they sought more relevance in subject matter, turning to everyday life for artistic motivation. They aspired to art that reflected the people as they were, and that necessitated acceptance of the urban setting and rejection of the "ideal" of peasant life as simply another artistic convention not based on reality. Reluctant to pose a composition, Impressionists explored the "fleeting moment" or the "temporal fragment" in ordinary life. Where the Realists yearned for a contemporary view of history, the Impressionists sought an instantaneous view.

If we look at the development of art as a continuum, then one can consider Impressionism as a technical elaboration of Realism. That elaboration produced paintings exhibiting bolder use of color and more convincing effects of natural light. The revolution in color use was heralded by several factors, notably the exploitation of newly

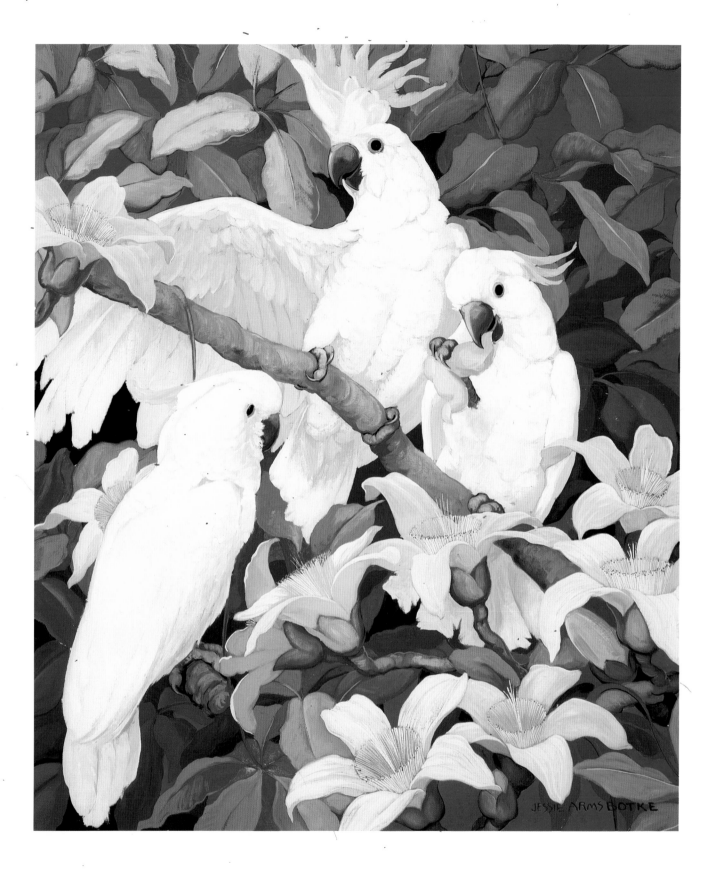

JESSIE ARMS BOTKE
Sulphur Crested Cockatoos, c. 1925
Oil on panel
30 x 25 inches

ANNA HILLS
Sycamores, n.d.
Oil on canvas
30 x 36 inches

WILLIAM WENDT
Sycamores and Oaks, c. 1903
Oil on canvas
30 x 40 inches

William Wendt's early style, prior to 1912-1915, tends closely to Impressionism, with long, delicate brushstrokes and a greater attention to space and atmosphere. Over time, Wendt pursued a singular manner where he flattened the composition and enlivened the surface of his paintings with areas of patterned, block-like applications of color.

published treatises on scientific investigations of color and light, as well as the development of chemically stable, more vivid paint pigments.

The most popular color theorist of the day was Eugene Chevreul, a consulting chemist in a tapestry factory. Charged with the responsibility of developing more vivid dyes, he deduced that the role of the chemist was not as consequential as the role of the artist, and that more brilliance could be attained by proper color placement than by stronger dyes. These findings and others by Chevreul were published in France in 1839 as *Laws of Simultaneous Contrast of Colors*. His most significant conclusions were adopted by the young Impressionist painters, including much of his findings on the role of complementary colors, that is to say colors that are opposite each other on the color wheel. Chevreul noted that the greater the difference between two colors, the more they will enhance each other when placed side by side, and inversely, the less the difference, the more they will tend to injure one another. Also, he stated that the apparent intensity of color does not depend as much on the inherent pigmentation as it does on the hue of the adjacent color. These laws of color placement were studied and systematized by the Impressionists. Proper use of these principles achieved a painting with a brilliant and intense light effect. When compared to the more tonal and poetic color scheme of Barbizon paintings, the contrast was immediate and conspicuous.

The Impressionist exhibition of 1874, held in Paris, included the following artists: Paul Cézanne (1839–1906), Edgar Degas (1832–1917), Edouard Manet (1832–1883), Claude Monet (1840–1926), Camille Pissarro (1830–1903), Pierre-Auguste Renoir (1841–1919), and the Englishman Alfred Sisley (1839–1899). Frederic Bazille (1841–1870) had been one of the original group of friends who painted together, but he was killed in 1870 fighting in the Franco-Prussian War. These young artists shared a strong philosophical conviction with the Realists and the Romantic-Realists of the Barbizon School. All of them pursued a perceptual, nonacademic, nonreligious, essentially naturalistic approach to art. Their art was founded on nature and on people.

The advent of Impressionism on the French art world was greeted with scorn and hostile criticism. It was regarded by most art writers as an insult to the museum-going public. Furthermore, its affiliation to Realism endowed it with references to social activism and political radicalism. The paintings themselves proved resistant to popular tastes. Because the artist worked quickly to capture the fleeting light effect, the completed work had a raw and unfinished appearance, especially when compared to the highly polished surface of an academic painting. The strong and often intense color schemes offended the tastes of a public accustomed to subtle tones. Furthermore, many of the subjects, such as ordinary people eating lunch or walking about the boulevards, were considered base and unworthy of attention as fine art.

WILLIAM LEES JUDSON
Ranch House, n.d.
Oil on canvas
15 x 25 inches

Maurice Braun in his studio, San Diego, 1918. Photo courtesy of Charlotte Braun White.

By contrast, the introduction of Impressionism in the United States, sometime about 1885–1890, was favorably received. The ensuing decade between its introduction in Paris and that in America had allowed much of the incipient hostility to dissipate. Many of America's leading artists had been students in Paris in the early 1870s. As students, they sought out the innovative and avant-garde fashion and were captivated by what they saw. When they returned home as professional artists, they promoted and championed Impressionism. Moreover, much of America's artistic traditions of the nineteenth century had developed along similar lines, and what was intimidating and unfamiliar to the French audience was looked upon with interest and curiosity by Americans.

Land and light had always been an integral part of American art. The Hudson River School, a group of early nineteenth century artists led by Thomas Cole (1801–1848) and Asher B. Durand (1796–1886) ventured into the "wilderness" of upstate New York. They were in awe of the beauty and grandeur of nature and developed a popular and long-lived style that centered on landscape as a primary subject. In a very real sense, they were the environmental activists of their day. At the same time, America produced a vigorous school of genre painters, most notably Winslow Homer (1836–1910), who specialized in scenes of everyday life in a country that, at the time, was characterized by farms and small towns.

The first exhibition of French Impressionist paintings in America was held in Boston in 1883. The display consisted of works by Monet, Pissarro, and Sisley, among others. Mary Cassatt (1844–1926), an American painter living in France, was accepted as a member of the group and participated in later exhibitions. Theodore Robinson (1852–1896) lived a great part of his short life in France and was one of the first American artists to return to the United States espousing Impressionism. In 1893 the World's Columbian Exposition in Chicago had a significant art section devoted to American Impressionist painters, and in 1898 "The Ten" was formed in New York. "The Ten" was a group of professional Impressionist artists who organized to exhibit and sell their paintings. Among the better known members of "The Ten" were Frank W. Benson (1862–1951),

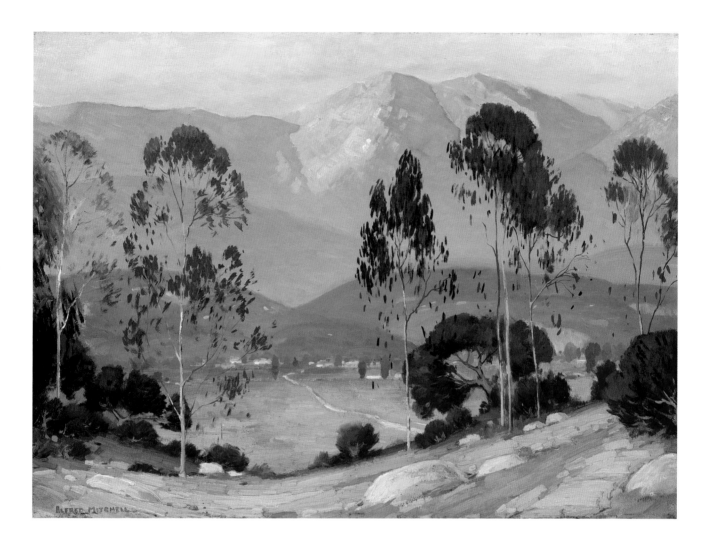

ALFRED MITCHELL
Sunset Glow, California, c. 1924
Oil on board
24 x 32 inches
Courtesy DeRu's Fine Arts

*Alfred Mitchell painted San Diego in
brilliant colors and with an intense
passion for realism. His paintings reveal
his keen sense of drama and his deep
spirituality. This remarkably lyrical
work was one of the artist's favorites
which he exhibited frequently
beginning in 1925.*

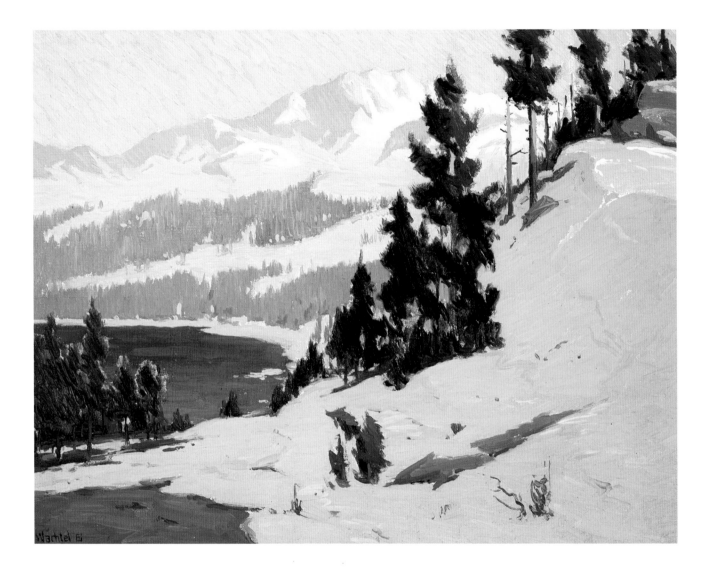

ELMER WACHTEL
Convict Lake, n.d.
Oil on canvas
16 x 20 inches

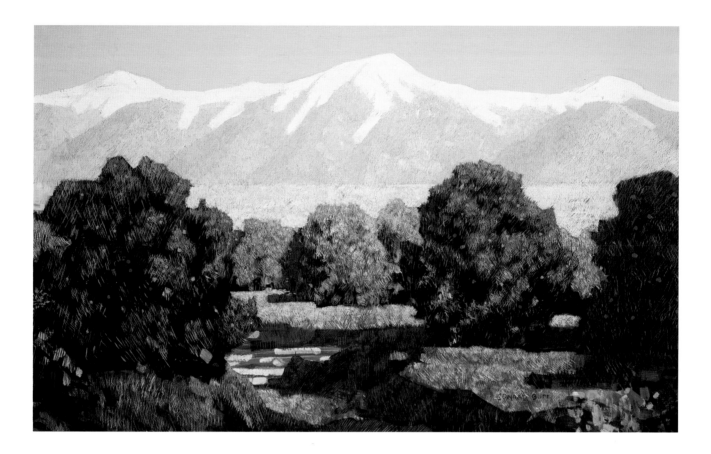

CONRAD BUFF
California orange grove, n.d.
Oil on board
21³/₄ x 34³/₄ inches

Although a contemporary and friend of the leading impressionist painters in California, Conrad Buff was an individualist who developed a unique style grounded in modernist ideas. Interested in surface textures, Buff first painted the forms in a semiabstracted manner in a simple, horizontal composition. He then covered the forms with an overall pattern of distinctive hatch-like lines.

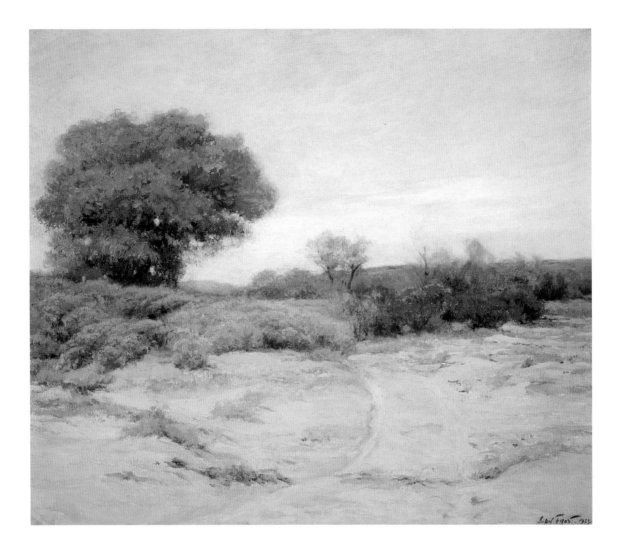

JOHN FROST
Autumn Oak, 1921
Oil on canvas
26 x 30 inches

John Frost, along with his painting companions Alson Clark and Guy Rose, pursued a more delicate, "French" style of Impressionism. Reminiscent of Monet's technique, Frost utilized small, delicate brushstrokes, with a subdued line, softer forms, and a carefully harmonized color scheme.

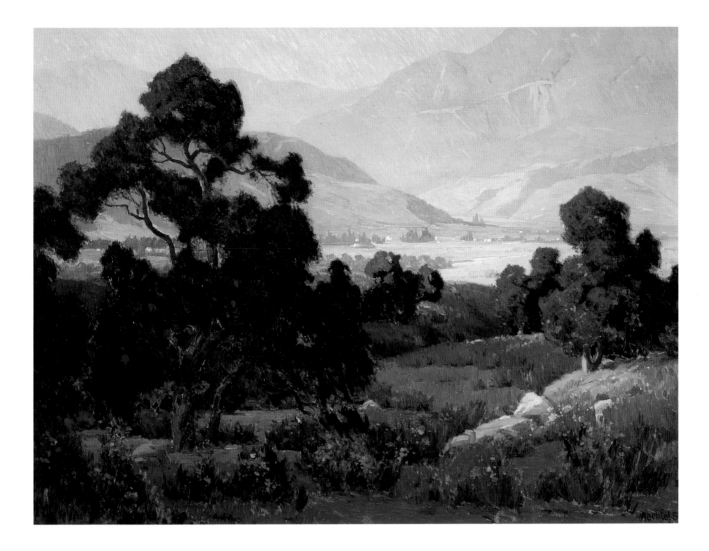

ELMER WACHTEL
Santa Paula Valley, c. 1903
Oil on canvas
30 x 40 inches

Elmer Wachtel was a multifaceted artist. He was an excellent painter in both oil and watercolor and was a violinist in the symphony orchestra. His paintings evolved from being firmly in the Barbizon style of the nineteenth century to a hybrid making more use of the color aesthetic of American Impressionism.

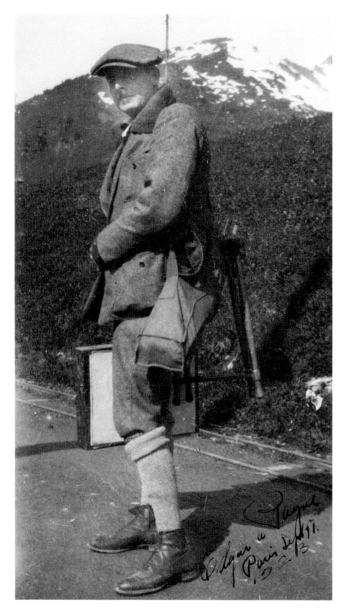

Edgar Payne sketching in the
Swiss Alps, 1923. Photo courtesy of
DeRu's Fine Arts, Bellflower.

William Merritt Chase (1849–1916), Childe Hassam (1859–1935), Edmund Tarbell (1862–1938), and J. Alden Weir (1852–1919).

By 1900, Impressionism, or what may be more properly termed "Impressionistic Realism," was the style of choice among American painters. Stylistically, it was a modified and somewhat tempered variant of the prototype French movement. The significant contributions of French Impressionism to American art were in the use of color and the specialized brushwork. The scientific theories of color, as promulgated by Chevreul, were indeed well received by Americans, and the outcome was observed in paintings with brilliant and convincing effect of natural light. The loose, choppy brushstroke that characterizes an impressionist work was both the consequence of the quick manner of paint application and the desire to produce a brilliant surface covered with a multitude of small daubs of bright color.

Coinciding with the advent of Impressionism in America, California was just commencing a period of rapid population expansion. The opening of the transcontinental railway in 1869 had made passage west to San Francisco safer and quicker than the overland horse-drawn vehicle route, or the tedious and perilous voyages across Panama prior to the existence of the canal. In 1876 a railroad route was opened between San Francisco and Los Angeles, and, in 1885, a southwest route from Chicago to Los Angeles was completed.

These improvements in travel between east and west led to the first of many successive land booms in Southern California. With the influx of population and commerce, California attracted professional artists. Northern California, with its social and cultural center in San Francisco, enjoyed a well-established art community dating back to the middle of the nineteenth century. Artists such as Virgil Williams (1830–1886), William Keith (1839–1911), and Thomas Hill (1829–1908) were working in San Francisco as early as 1858. Williams was trained in New York and studied in Rome before coming west. In 1874 he was hired as the director of the newly opened San Francisco Art Association School of Design. A well-loved and respected teacher, he trained a large number of art students including the redoubtable Impressionist Guy

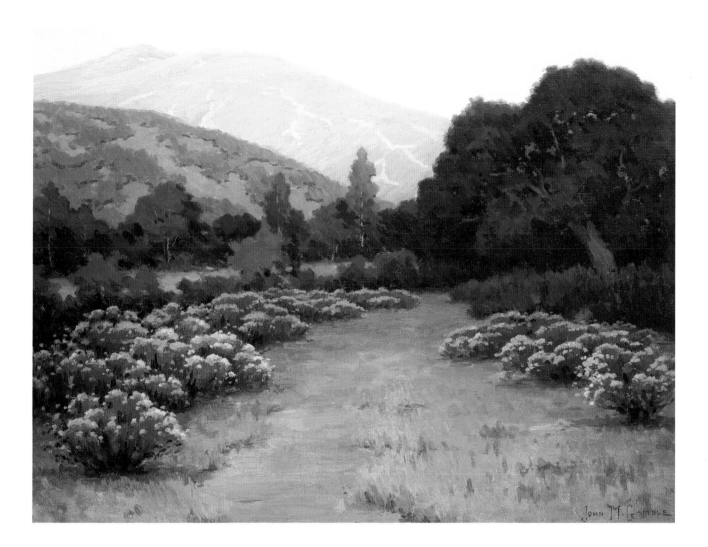

JOHN GAMBLE
The Last Rays, c. 1915
Oil on canvas
20 x 26 inches

Whereas much has been stated regarding the difficulty in presenting a true and convincing effect of bright, natural light, it is interesting to see how an impressionist deals with faint light. Gamble retained a significant amount of clarity and detail in a subdued foreground as he highlighted the composition with a striking sky effect.

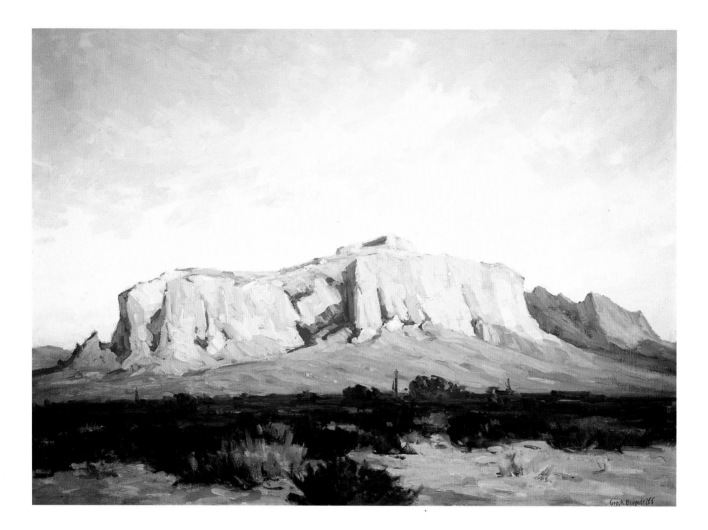

GEORGE BRANDRIFF
Superstition Mountain, c. 1928
Oil on canvas
30 x 40 inches

Trained as a dentist, George Brandriff forsook science for art midway through his career. He quickly matured as an artist, working in a personal style often laden with feelings of separation and solitude. Superstition Mountain, *painted in Arizona, draws the viewer into a dramatic realm, evoking the fateful power of the desolate desert.*

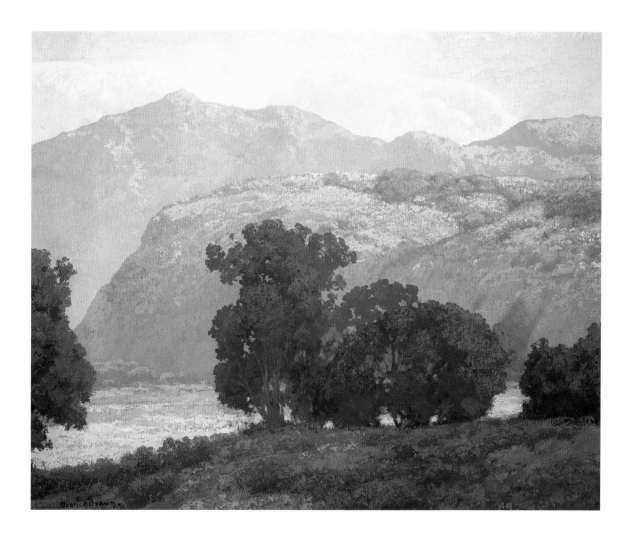

MAURICE BRAUN
California Hills, 1914
Oil on canvas
40 x 50 inches

"Maurice Braun was an artist of deep philosophical conviction for whom all expressions of life were divine. So it is natural that in the look and feel of his work you should find pastoral peace. This peace is born of his sense of wholeness. Through an interplay of religious respect and aesthetic resolve he found equilibrium and this was for him, as it can be for us, the secret of life itself."—John Fabian Kienitz, 1954.

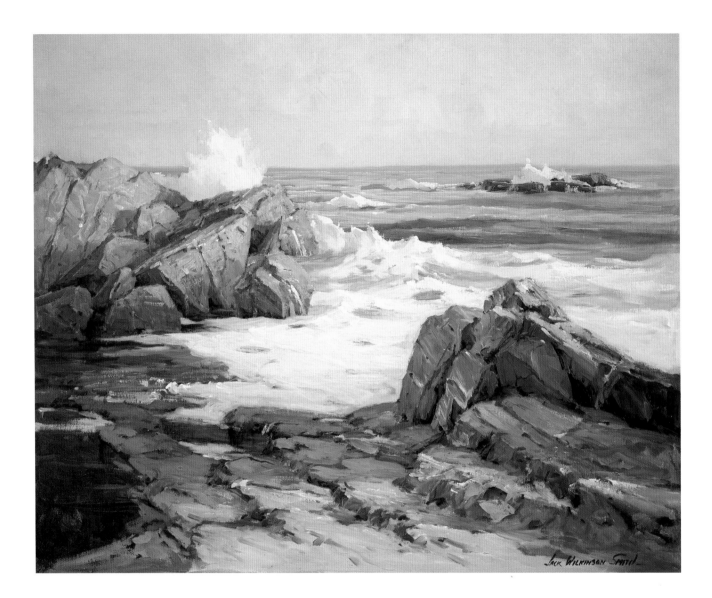

JACK WILKINSON SMITH
Evening Tide, California Coast, c. 1915
Oil on canvas
30 x 36 inches

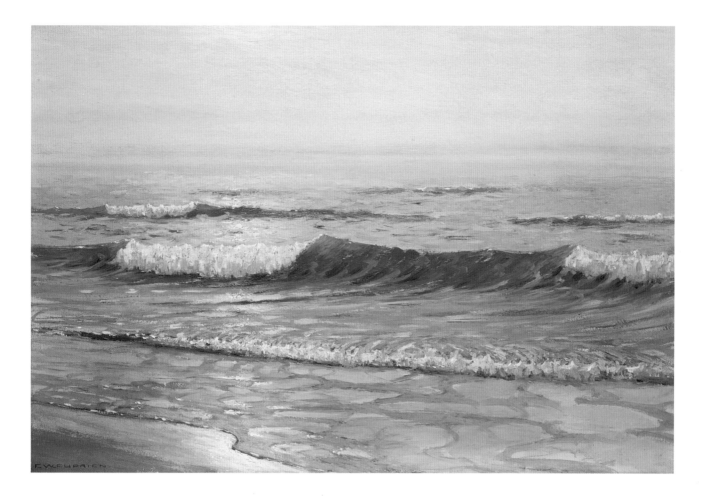

FRANK CUPRIEN
An Evening Symphony, n.d.
Oil on canvas
18 x 26 inches

Frank Cuprien embraced the discipline of seascape painting and raised it to a personal form of expression. He studied the light and form of the sea, exploring its diversities in all seasons and at all intervals of the day. A great number of his sketches are titled merely with the date and time of day. He stands unequalled in this genre.

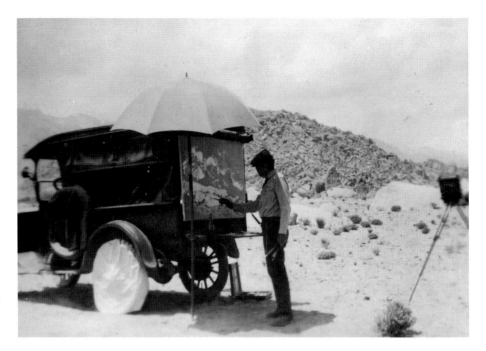

Rose (1867–1925). Keith was a prolific painter who specialized in pastorals in the Barbizon style, creating, at times, dark and moody scenes of forest interiors with occasional cattle or sheep in the thickets. Called "California's Old Master" in his later years, Hill was best known for his majestic views of Yosemite. He built a studio in the park in 1883 and was credited with over 5,000 paintings of that locale.

All three of these pivotal artists were trained in academic European styles and achieved maturity prior to the advent of Impressionism. As such they represented an entrenched artistic tradition that effectively inhibited the establishment of an impressionist aesthetic in San Francisco until well after the turn of the twentieth century. In consequence, young artists looking to settle in California turned south. Much had been offered about the desirability of the Southern California climate, with its generous numbers of sunny days, or of the southward migration caused by the San Francisco earthquake of April 1906, as motivations for the advent of Impressionism in the south. Both factors exerted influence to some extent; however, an added motivation was surely economic opportunity. Los Angeles, at the time not having a substantial artistic establishment, became the alternative metropolitan center that absorbed the infusion of young artists in California in the late nineteenth century.

In time a large group of artists settled in Southern California and, by 1915,

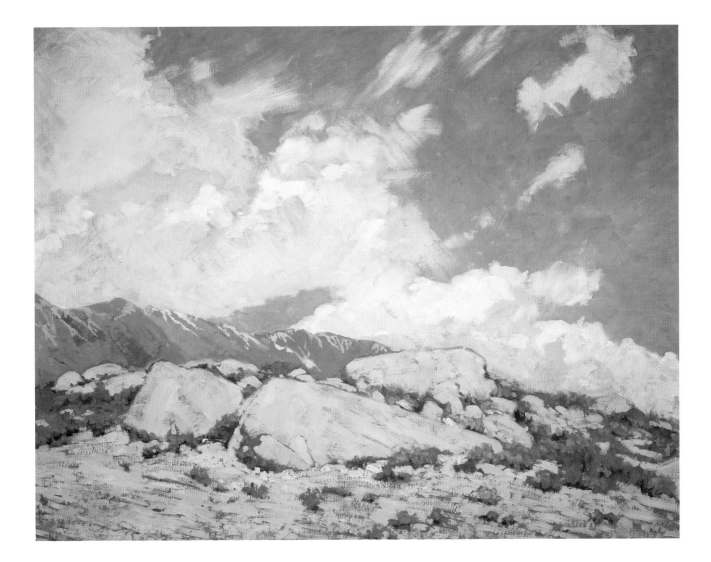

ALSON CLARK
California Mountains, c. 1922
Oil on canvas
36 x 46 inches

Alson Clark was a confirmed plein air painter, not only sketching out of doors but also painting large, final compositions in the field. California Mountains *was painted in the vicinity of Lone Pine, a small town near Mt. Whitney. The adjoining photograph of the artist shows Clark working on the painting at his mobile studio.*

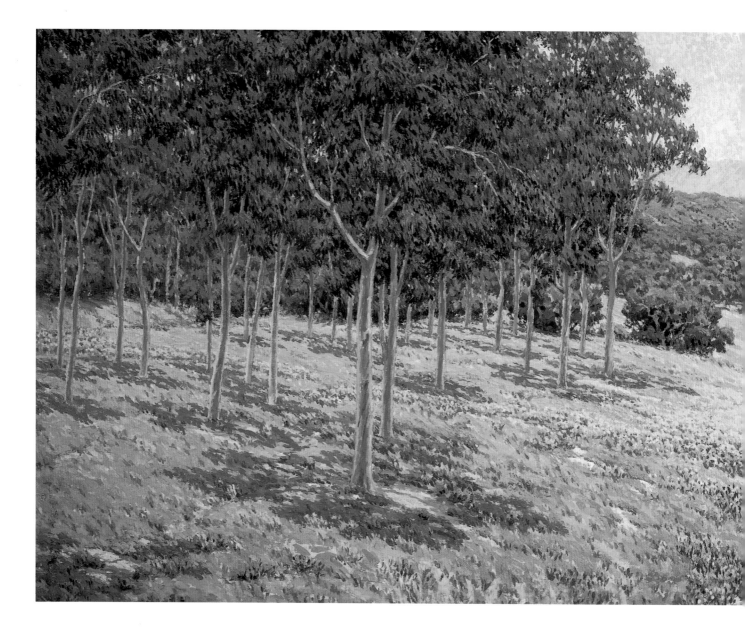

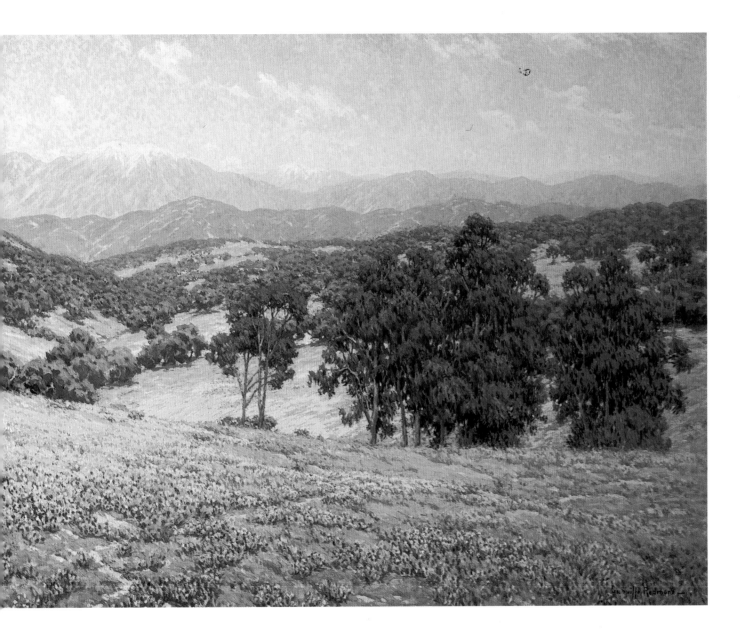

GRANVILLE REDMOND
California landscape with flowers, n.d.
Oil on canvas
32 x 80 inches

Among a large group of artists who painted the rolling hills of California's wildflowers, Granville Redmond's stature is paramount. Such colorful works were highly successful, selling well, and gaining distinguished patrons such as Charlie Chaplin. Ironically, Redmond preferred painting the tonal, moodier works which stand in sharp contrast to the poppy field paintings.

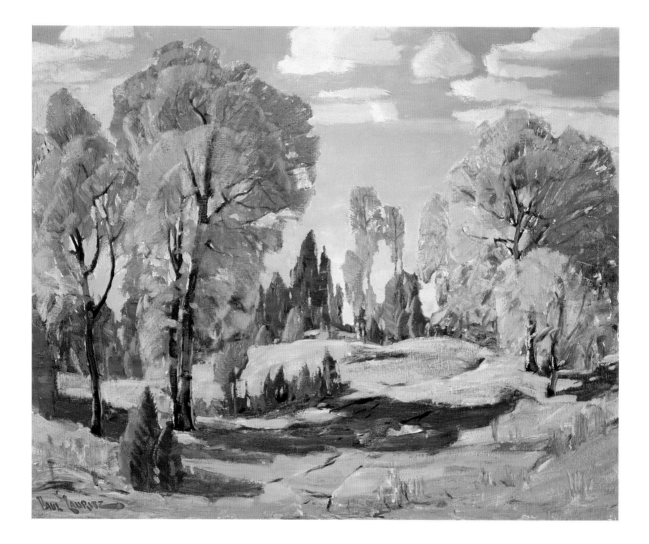

PAUL LAURITZ
Autumn Near Big Bear Lake, c. 1926
Oil on canvas
24 x 28 inches

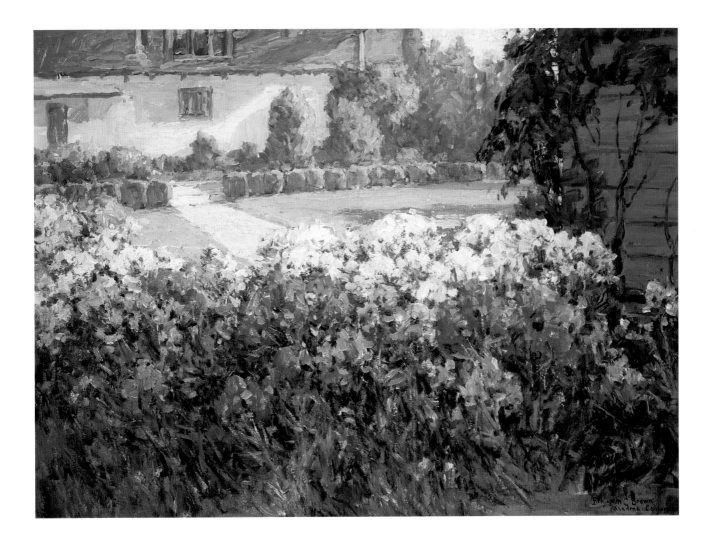

BENJAMIN BROWN
The Joyous Garden. n.d.
Oil on canvas
30 x 40 inches

The colorful abundance of flowers in the artist's garden creates a dramatic foreground. This contrasts with the simple representation of the house which is depicted in bright sunlight.

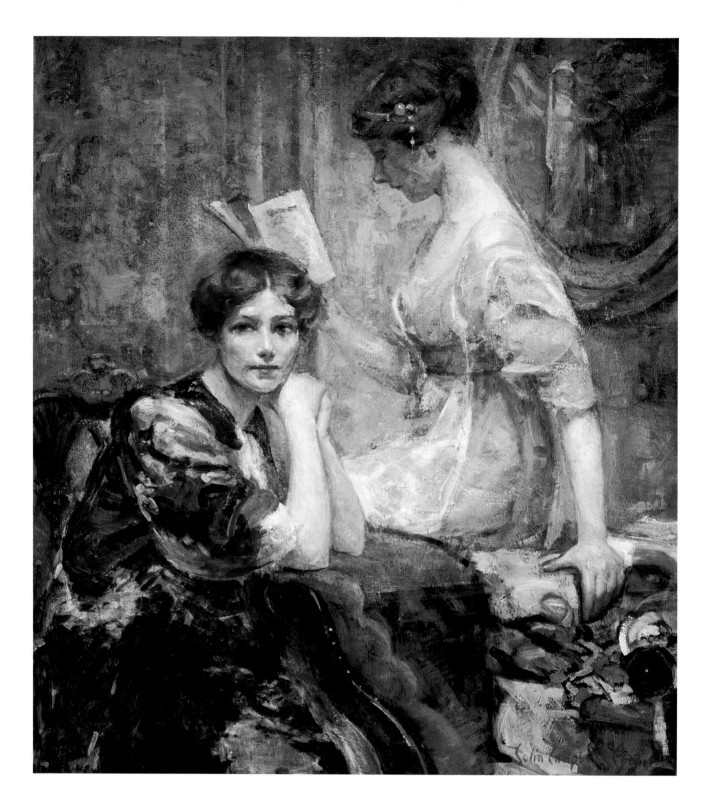

COLIN CAMPBELL COOPER
Two Women, n.d.
Oil on board
24$\frac{1}{2}$ x 21$\frac{1}{2}$ inches

the Plein Air painters had become the "entrenched establishment" with their coterie of dealers, patrons, and writers who functioned as an effective impediment to the imminent generation of Modernist artists. The 1930s heralded change. The Great Depression was an equal-opportunity affliction to all artists in California. Modernists as well as Plein Air artists joined in the Works Progress Administration programs, such as the Federal Arts Project which allotted mural commissions in public buildings. With economic recovery, Modernism made its inroads and, by the outbreak of World War II, most of the prominent names of California Impressionism had died or had withdrawn from the public eye, and the style itself became a nostalgic souvenir of a bygone era.

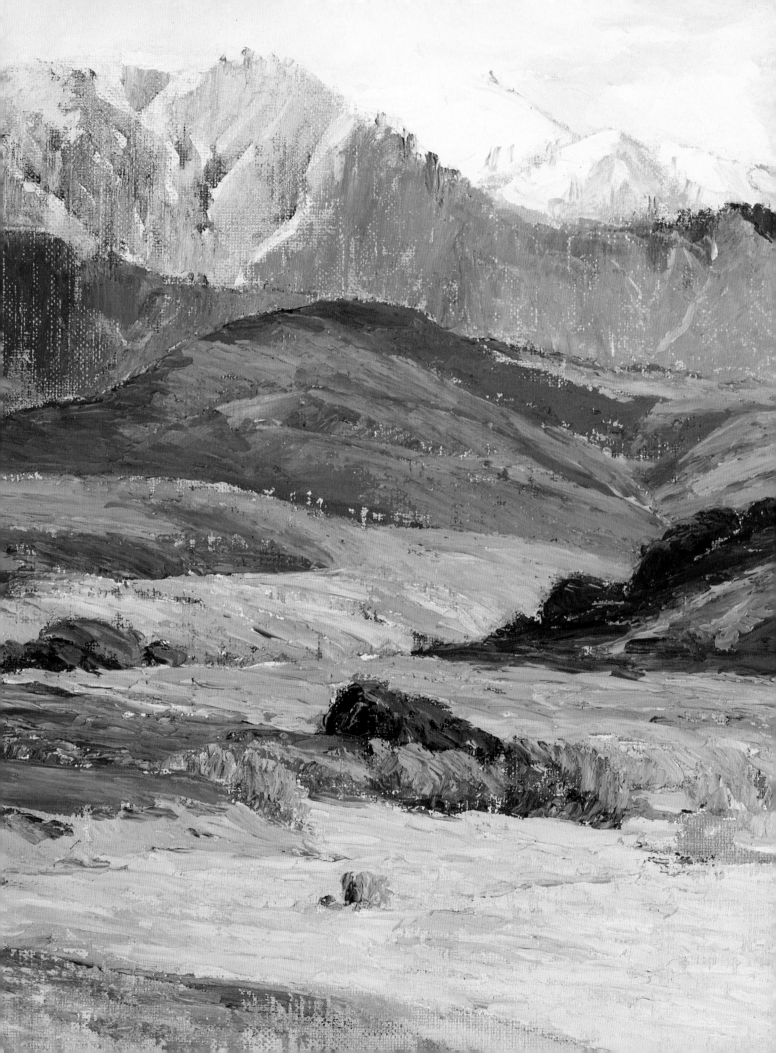

Southern California: The Lure of the Landscape

BY JANET BLAKE DOMINIK

WHEN THE FIRST ARTISTS came to California in the latter part of the nineteenth century, America had a strong artistic tradition of landscape painting dating from the middle part of the century when the artists of the Hudson River School espoused glorification of the landscape. That movement had gained further impetus through the writings of the English critic and artist John Ruskin, who called for the ideal description of nature through careful observation and accurate description.

Once rail transportation was established to Northern California in 1869, Eastern artists traveled to that part of the state. Romantic landscape artists Albert Bierstadt (1830–1902) and Thomas Moran (1837–1926) created large-scale, panoramic views of the wonder and beauty of the region. Thomas Hill (1829–1908), known for his paintings of Yosemite, and William Keith (1838–1911) were the leading exponents of romantic realism in Northern California at the end of the nineteenth century. Keith, the most important resident artist of that period, worked in a variety of styles encompassing the traditions of the Hudson River School and the romantic realism of Bierstadt. In 1891 George Inness (1853–1926) visited Northern California and found that the topography and climate there with its hazy light lent itself well to his tonalist aesthetic. Keith's works from that period reflect the tonalist influence of Inness.

Although a number of artists in Southern California at the end of the nineteenth century, such as Elmer Wachtel, William Lees Judson, Granville Redmond, and Charles Fries, also employed the tonalist aesthetic, the majority of works produced there from about 1900 are part of the American Impressionist movement which dominated the mainstream of art in the United States from about

ANNA HILLS, *San Gorgonio from Beaumont* (detail)

41

MAURICE BRAUN
La Jolla, n.d.
Oil on canvas
24 x 36 inches

*Maurice Braun's views of California
often encompassed panoramic vistas such
as this work which depicts the colorful
vegetation found along the southern
coastal region. His works are imbued
with a spiritual sense which was
grounded in his Theosophical beliefs.*

WILLIAM WENDT
Arcadian Hills, 1910
Oil on canvas
40¹/₂ x 55¹/₂ inches

William Wendt viewed nature as the manifestation of God which required that he interpret it with fidelity and sensitivity. Arcadian Hills *was exhibited at the Art Institute of Chicago in 1910 and 1911 and with the California Art Club in Los Angeles and San Francisco in 1911 and 1912. Antony Anderson heaped praise upon the painting for its beautiful interpretation and subtle atmosphere.*

1890 to 1930. When the first professional artists arrived in Southern California in the late 1880s, American artists had already begun to incorporate impressionist theories in their work—notably, the formal qualities of concern for light, color, and atmosphere, the technique of broken or feathery brushstrokes, and painting out of doors or *en plein air.*

Southern California's rich topography, its year-round temperate climate, and the perennial sunshine, made it a haven for the landscape painters, and others who were primarily figure and portrait painters, soon succumbed to the lure of the landscape. The light in the southern part of the state was especially brilliant, and it illuminated and changed the character and contour of the landscape. Rich and varied color was seen year-round, ranging from the many earth tones—greens, yellows, browns, and reds—to elegant blues and purples. *Art in California*, published in 1916, contained many references to the beauty of California. Perhaps the most romantic comment came from Michael Williams of the *San Francisco Examiner*, who described "the land of the great out of doors, a region where art may touch the life-giving bosom of Mother Earth once more, and be fructified anew."[1] Such sentiments were repeated by William Howe Downes in 1920 in an article for *The American Magazine of Art,* who referred to an "embarrassment of riches" in "the vast domain of California, with its long line of coast, its majestic mountains, and its fertile valleys."[2]

Downes' article was illustrated with paintings by Benjamin C. Brown, one of the earliest professional artists to settle in Southern California, having first visited the area in 1886 before settling permanently ten years later. An avid exponent of impressionist theory and technique, he described his artistic principles as an interest in "the play of light and shade on objects of nature," thus creating pictures, which although realistic would be composed and balanced to achieve the most decorative effect.[3] In fact there seemed to be a consensus of opinion that Impressionism was the best method for interpreting the landscape in Southern California. *Los Angeles Times* art critic Antony Anderson stated that it was the only method permitted in the painting of the landscape.[4] Mabel Urmy Seares, writing in *California Southland*, declared that "not until the advent of broken color, brilliant contrasts and direct painting from nature in its modern high key has . . . the southern part of the State found true interpretation."[5] She later wrote: "To paint the brilliant sunshine is here the shibboleth which betrays the novice or distinguishes the master in his choice of what and how to paint."[6] Artists trained in the East or in Europe found that they had to completely revise their palette, nearly eliminating the cooler, grayer tones in favor of the warmer and lighter hues. It was a challenge to which many artists succumbed, but to which few succeeded.

The American-born professional artists who came to Southern California

JOHN GAMBLE
Joyous Spring, c. 1924
Oil on canvas
26 x 20 inches

Eastern patrons found it difficult to believe the veracity of John Gamble's colorful depictions of the wildflowers of California. Those who ventured to California in the spring soon found their doubts relieved. Such paintings were given the affectionate label, "Gamble's Prairie Fires."

JACK WILKINSON SMITH
San Gabriel Mountains, n.d.
Oil on canvas
24 x 30 inches

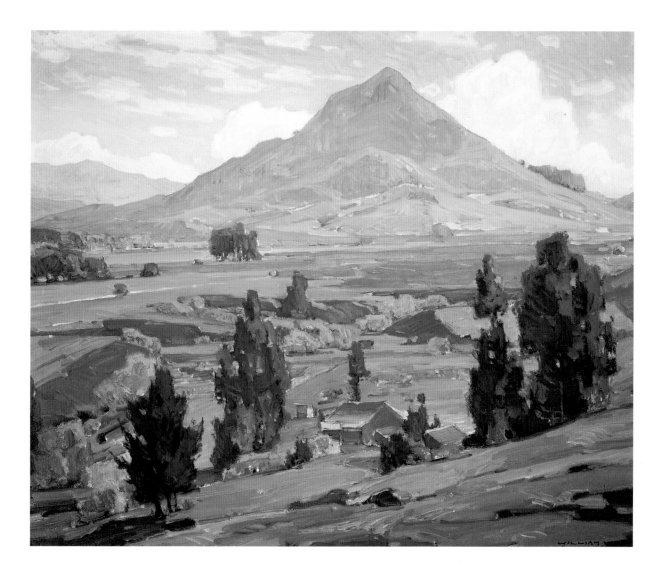

WILLIAM WENDT
The Soil (Near San Luis Obispo), 1926
Oil on canvas
30 x 36 inches

*In the mid 1920s, William Wendt regularly
painted the landscape in central California
near San Luis Obispo. It was surely his most
productive period, as these works exhibit
heightened color, elaborate composition, and
a powerful sense of spirituality.*

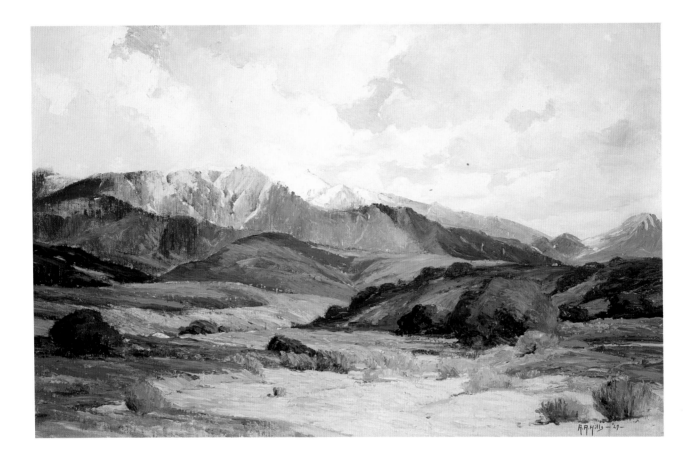

ANNA HILLS
San Gorgonio from Beaumont, 1927
Oil on canvas
20 x 30 inches

*Antony Anderson remarked that Hills despaired that
she could not reach the high key of the brilliant light
she found in Southern California, even after
discarding all the gray tones from her palette and
using instead pure blues, reds, yellows, and, of course,
white. (Los Angeles Times, 16 November 1913)
In this painting she succeeded.*

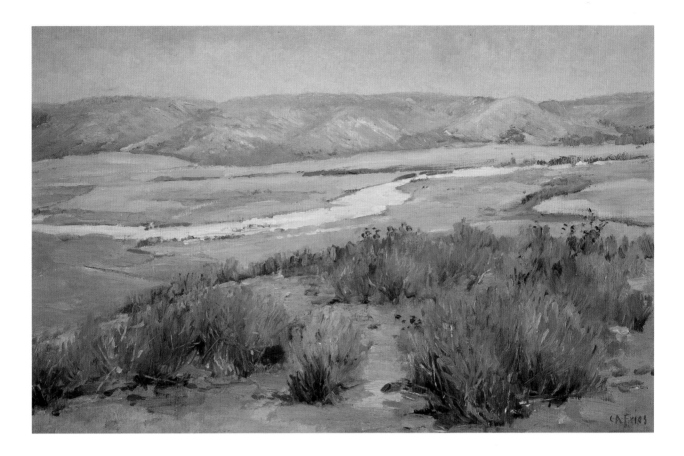

CHARLES FRIES
Looking Down Mission Valley, Summertime, 1905
Oil on canvas
18 x 28 inches

Mission Valley is named for the site of Mission San Diego de Alcala. Today this view encompasses Hotel Circle, two major shopping centers, several automobile dealerships, San Diego Stadium, an assortment of restaurants, and, finally, the historic San Diego Mission itself.

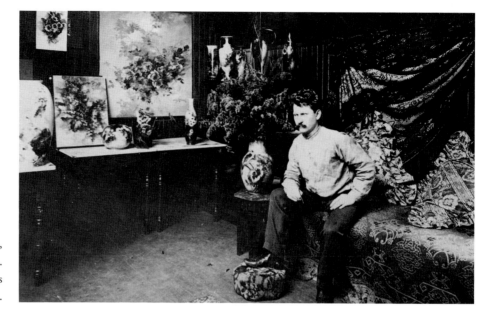

Franz A. Bischoff in his studio, Dearborn, Michigan, c. 1900–1905. Photo courtesy of Peabody's Fine Art Gallery, Sacramento.

received their training elsewhere in the United States—in San Francisco at the California School of Design (founded in 1874), at the Art Institute of Chicago, and in New York at the Art Students League and the National Academy of Design. It was also a tradition for American artists to complete their course of study in Europe, and the artists who flocked to France beginning in the 1870s studied impressionist methods first hand.

Towards the end of the century, a number of Americans settled in and around the village of Giverny where Claude Monet lived. Many hoped to associate with him. The California-born artist Guy Rose first visited Giverny in 1890, then spent several years there beginning in 1904. He developed an impressionist style which is strongly associated with other American Impressionist artists Frederick Frieseke (1874–1939), Lawton Parker (1868–1954), and Richard Miller (1875–1943), with whom he exhibited in New York in 1910 as the "Giverny Group." Rose also emulated Monet's studies of light by painting the same subject matter at different times of day and in different seasons, a practice he continued after he returned to California.

Also in France at Giverny was the American painter Alson Clark, who was educated at the Art Institute of Chicago and at the Art Students League with William Merritt Chase (1849–1916). An inveterate traveler, he made numerous trips to France, the first in 1898, where he studied in the atelier of the expatriate American James Abbott McNeill Whistler (1834–1903), who would be an influence for many years. During Clark's visit to France in 1910, he spent time at

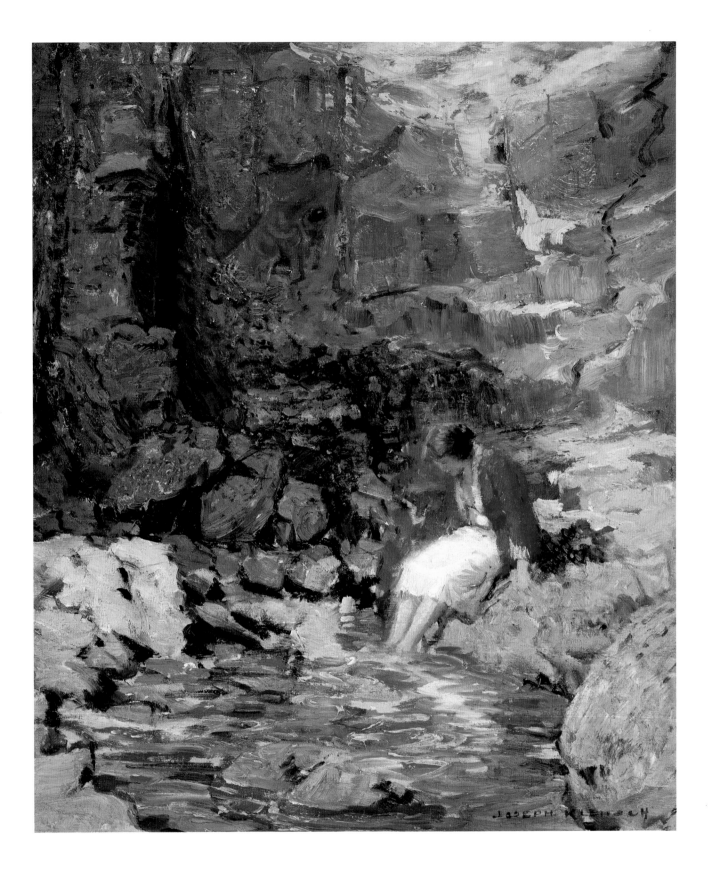

JOSEPH KLEITSCH
Enchantment, c. 1922
Oil on canvas
22 x 18 inches

Joseph Kleitsch's strength as a colorist is seen in this remarkable painting which depicts his young wife cooling her feet in a mountain stream.

51

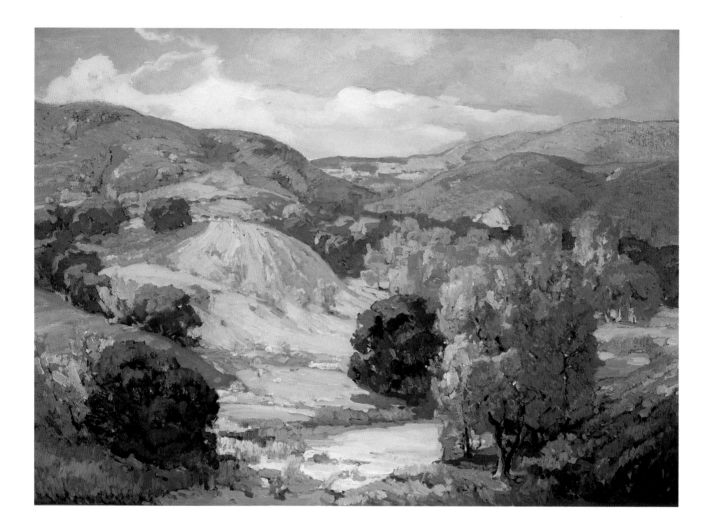

FRANZ BISCHOFF
Untitled landscape, c. 1915
Oil on canvas
22 x 30 inches

*Bischoff "brings to landscape [an] exquisite sense
for color. . . [and it is] not always the landscape
that you or I see; it is far lovelier, it has melting
harmonies that no one but Mr. Bischoff sees."*
—Antony Anderson, 28 May 1922

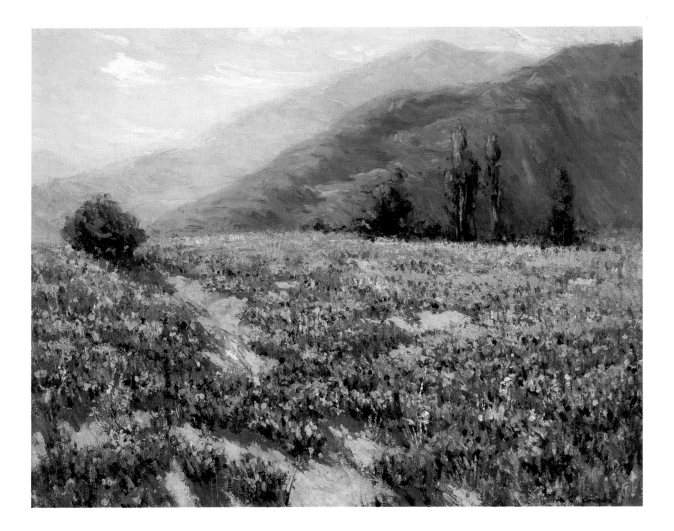

BENJAMIN BROWN
Poppies Near Pasadena, n.d.
Oil on canvas
14 x 18 inches

The profuse carpets of wildflowers found in the countryside of California in early spring were a natural subject for the artists. The most prevalent flowers were the golden orange blooms of the California poppy, but equally popular were the blue lupines and the bright yellow wild mustard.

Giverny where he associated with Frieseke, Parker, Rose, and their families. Thereafter the influence of Impressionism appeared in his work.

Rose returned to Southern California in 1914, and Clark settled there in 1920. By that time there was a well-established group of artists who had been working for a number of years, interpreting the landscape each in his or her own individual way while utilizing impressionist methods and techniques. These artists included Franz Bischoff, Maurice Braun, Benjamin Brown, John Gamble, Anna Hills, William Lees Judson, Jean Mannheim, Hanson Puthuff, Granville Redmond, Donna Schuster, Gardner Symons, Elmer Wachtel, Marion Kavanagh Wachtel, and William Wendt.

These artists established studio-homes in and around Santa Barbara, Los Angeles, and San Diego. Jean Mannheim, Franz Bischoff, and Elmer and Marion Wachtel resided along the Arroyo Seco in Pasadena. Elmer Wachtel had arrived in California in 1882. Although many of his works reflect the tonalist aesthetic, he also employed the higher-keyed palette of Impressionism; at times he combined the two in a dramatic composition utilizing a dark foreground contrasted against a lighter background. Anderson described his works as "something new and strange, [having] an epic solemnity and grandeur, with here and there a quick and vibrant touch of keen beauty which is truly lyric."[7] Marion Kavanaugh had studied in the north with William Keith before moving south and marrying Elmer Wachtel in

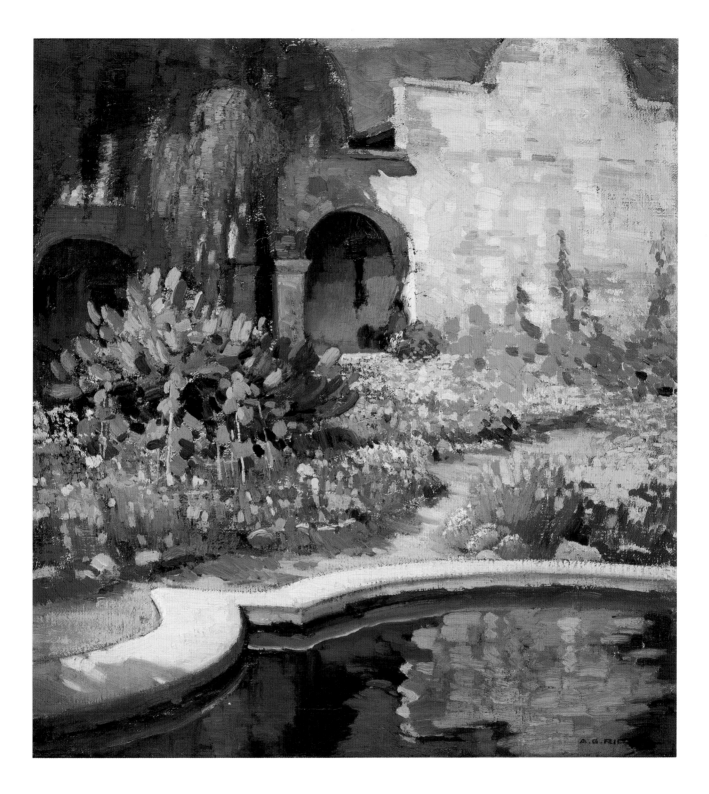

ARTHUR RIDER
Mission Garden, San Juan Capistrano, c. 1929
Oil on canvas
22 x 20 inches

Among the best colorists in America, Arthur Rider was greatly influenced by the Spanish Impressionist Joaquin Sorolla (1863–1923). Rider spent several summers in Valencia, absorbing the light and color of Spain. He came to California in 1928 and remained the rest of his life.

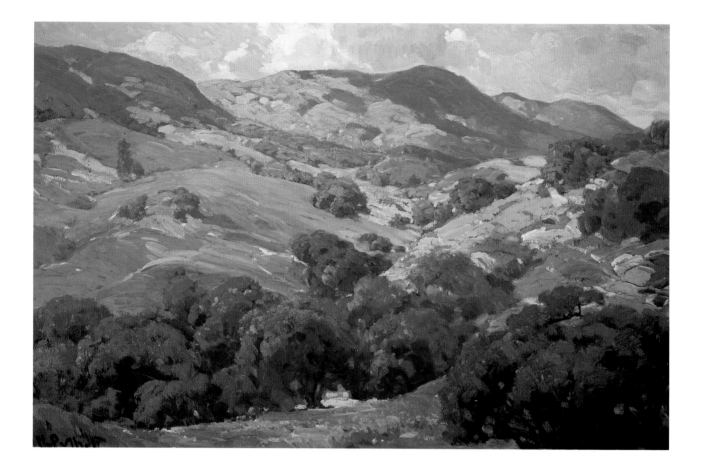

HANSON PUTHUFF
Topanga in Spring, n.d.
Oil on canvas
24 x 36 inches

Topanga Canyon was a favorite painting location for Southern California artists. In the early 1900s the only access to the canyon was by stagecoach up a winding roadway. Hanson Puthuff was a true plein air painter, completing his works in one sitting in order to capture the subtle changes and nuances of nature.

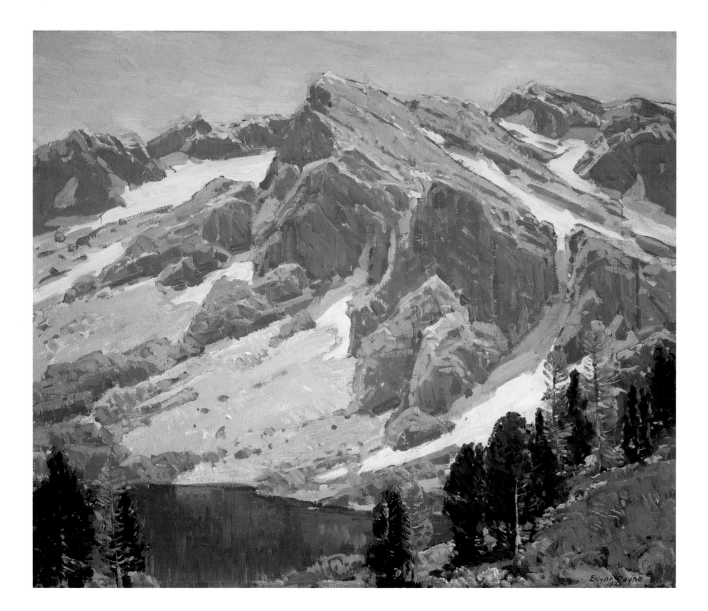

EDGAR PAYNE
Sierra Divide, 1921
Oil on canvas
24 x 28 inches

Edgar Payne painted the Alps in Switzerland and France. In California, his name so closely came to be associated with views of the California Sierras that he was called "God of the Mountains" by Fred Hogue, chief editorial writer for the Los Angeles Times. Sierra Divide *is perhaps Payne's best known work in this genre, having been reproduced in many contemporary and recent art publications.*

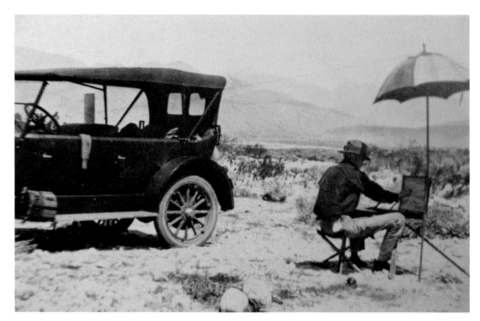

Benjamin Brown painting near Palm Springs, c. 1920. Photo by Alson S. Clark courtesy of Alson Clark III.

1904 (thereafter writing her maiden name as Kavanagh). She worked primarily in transparent watercolor, and her paintings convey a wonderful sense of the light and atmosphere of Southern California.

One of the most important colonies was established in the coastal community of Laguna Beach. It had been visited by William Wendt and Gardner Symons as early as 1896. By 1915 there were a number of resident artists, as well as artists from Los Angeles and elsewhere who maintained studios there. For many years they sold paintings along the roadside until finally, in 1918, they formed the Laguna Beach Art Association and opened their first gallery.

Having established residency in Laguna Beach in 1912, William Wendt was perhaps the most dedicated painter of the landscape in Southern California. For Wendt the Southern California landscape was "nature's temple," which he glorified through his paintings. Wendt's early works, such as *Sycamores and Oaks*, c. 1903, are more closely aligned with impressionist theory and technique, both in tonality and in the feathery brushwork. However, it is with his later works that he developed an original style with a distinctive block or hatch-like brushwork giving solidity to natural forms. The change in his style was first noted by Antony Anderson in 1912:

> Has the lesson of the cubists been conned by William Wendt? I almost thought it had when I looked at the four beautiful landscapes I saw—or thought I saw—cubic signs in the shape of his clouds and the modeling of his live oaks. However this may be, I felt sure of one thing—that William Wendt had "arrived," and that he is a big

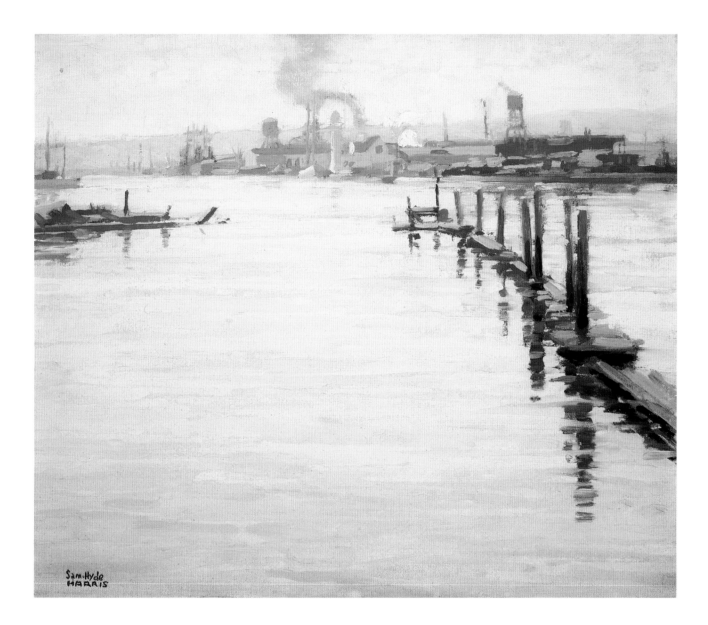

SAM HYDE HARRIS
Todd Shipyards, San Pedro, c. 1935
Oil on canvas
20 x 23 inches

Sam Hyde Harris was one of the few plein air painters to acknowledge the urban setting as well as the landscape. Here, by raising the horizon line, he allowed the viewer to contemplate the effects of fading light on the rippling water.

GRANVILLE REDMOND
Southern California Hills, n.d.
Oil on canvas
25 x 30 inches

In 1931 Los Angeles Times *art critic Arthur Millier noted that Redmond, at the age of sixty, remained "unrivaled in the realistic depiction of California's landscape." Such works, he noted, were "at one and the same time completely realistic in treatment, yet obedient to a subtle, personal conception of form, design and color." The poppy field paintings may have been thought of as "potboilers," yet Redmond displayed "his remarkable understanding of color and depth and his sympathy with the delicate beauties of nature." (22 March 1931)*

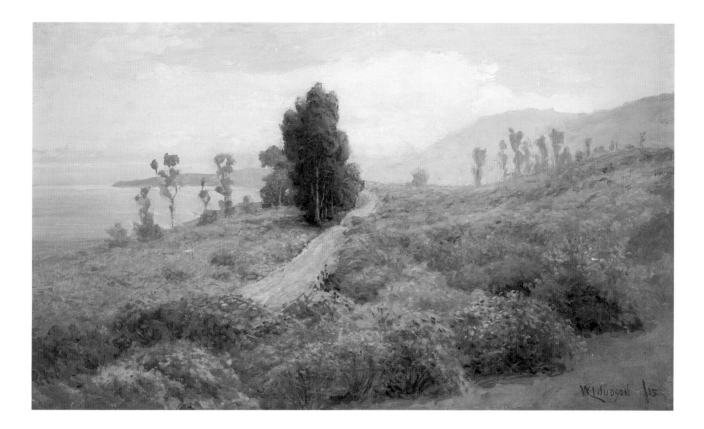

WILLIAM LEES JUDSON
Laguna Hills, 1915
Oil on canvas
18 x 30 inches

In a review of Judson's work in 1910, Los Angeles Times
*art critic Antony Anderson noted: "In his handling of light,
indeed, Mr. Judson has achieved a decided success."
Anderson praised the artist for "breadth of handling,"
"simplicity of feeling," and "vivid and alluring color."
(16 October 1910) The founder of the art department at
the University of Southern California, Judson painted in
many locales, including Topanga Canyon, the Arroyo Seco,
Laguna Beach, and Catalina.*

Frank Cuprien
Santa Monica Mountains,
from Old Pier, 1910
Oil on canvas
20 x 28 inches

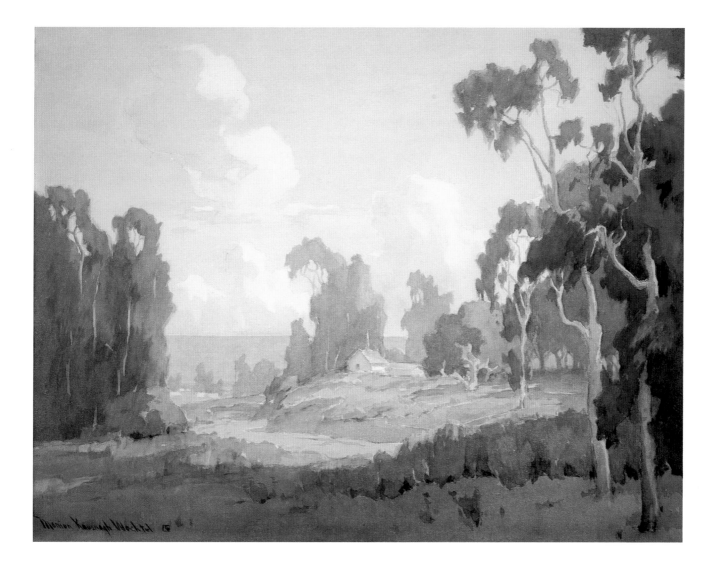

MARION KAVANAGH WACHTEL
Summer Afternoon, Santa Monica, c. 1917
Watercolor on paper
Sight 16 x 20 inches

Marion Wachtel was considered one of the foremost watercolorists of the plein air style in her day. She was able to impart the delicate atmosphere of the scene with careful applications of transparent washes, sometimes accented with pastel. After her marriage to Elmer Wachtel in 1904, it was said that she chose to work in watercolor, a challenging, unforgiving medium, so as not to overshadow her husband's works in oil.

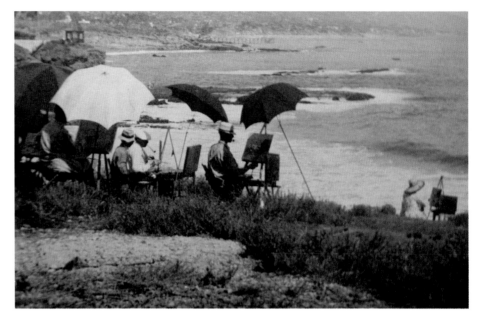

Outdoor painting class,
Laguna Beach, early 1920s.

artistic personality, much bigger than he was last year. He has a technique of remarkable vigor and directness, a deep knowledge of nature, a high aim. Nothing trivial or unconsidered ever comes from his brush. . . . [8]

It is in the message of the solidity and the massiveness of the California landscapes that sets these artists apart from their French counterparts, or, for that matter, from impressionist painters in the Eastern United States. This may well have had to do with a natural response to an impressive and inspiring landscape. Artists took periodic and extensive trips in search of ideal painting locations—to the canyons, the mountains, the desert, and the coast. Their journeys were frequently reported by Antony Anderson who described the life of the landscape painter as being part "pack mule," having to haul canvas, easel, umbrella, paint box, brushes, palette, lunch box, canteen, oil, turpentine, rags, etc., etc., and then having to fight the elements including heat, dust, wind, rain, bugs, rattlesnakes, and assorted wild and domestic animals, especially bulls. [9]

Usually such travels began by automobile, specially outfitted for such trips, but often ended on horseback in some of the regions not accessible by car. Conrad Buff recalled one such journey which he undertook with Franz Bischoff, an adventure which took them to the High Sierras where they finally joined the elaborate encampment of artist Edgar Payne and his family. [10] Payne, who traveled extensively throughout the Sierras, was best known for his dramatic works recording the pristine beauty of that mountain setting. His interpretations ranged from

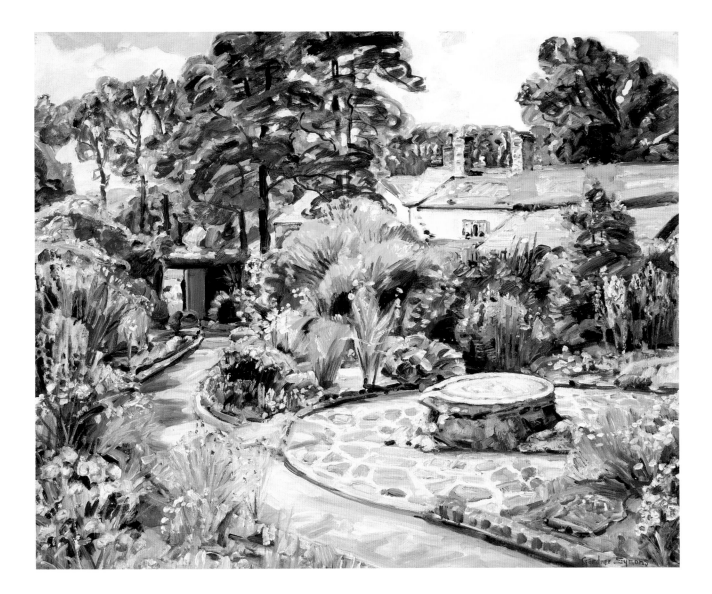

GARDNER SYMONS
Laguna, n.d.
Oil on canvas
25 x 30 inches

Gardner Symons divided his time between the West Coast and the East and also spent time in Cornwall, England. This scene, showing the lush flowers and foliage at his home in Laguna Beach, is a quintessential celebration of California.

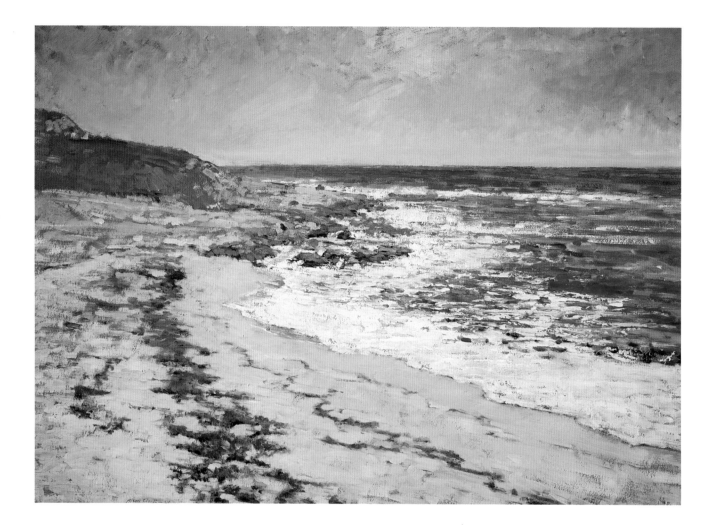

ALSON CLARK
La Jolla Seascape, 1924
Oil on board
35 x 47 inches

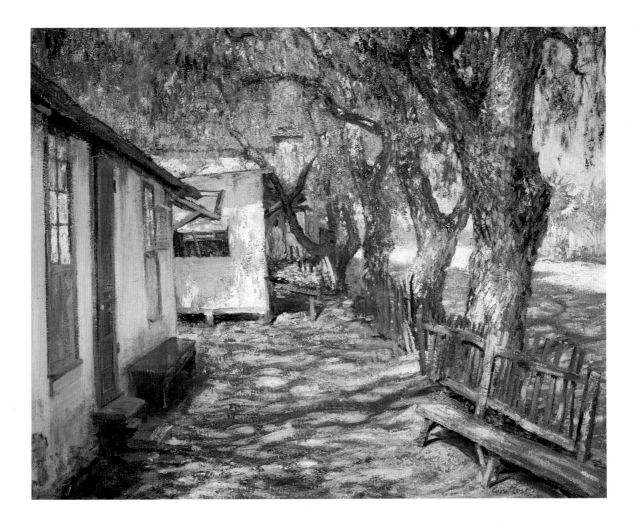

GUY ROSE
San Gabriel Road, c. 1914
Oil on canvas
24 x 29 inches

Guy Rose is the only major artist of the plein air style who was born in California and who had a direct association with the French Impressionists, being a neighbor of Claude Monet during Rose's stay in Giverny from 1904 to 1912. Upon his return to California in 1914, Rose painted this work at the San Gabriel Mission in a style truly evocative of Monet.

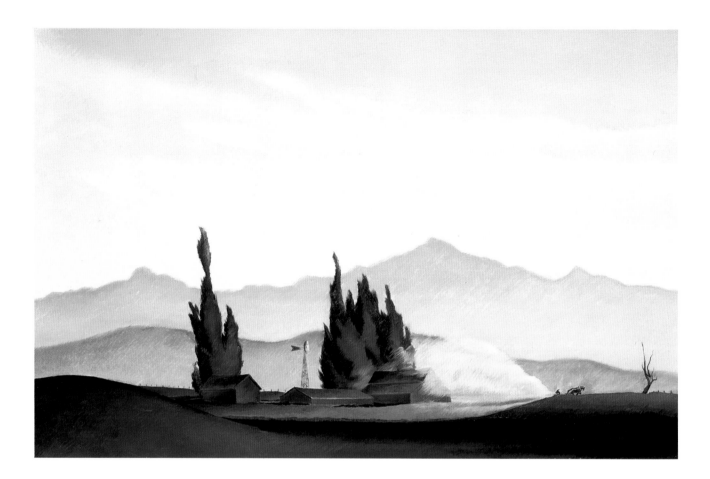

TOM CRAIG
California, c. 1936
Oil on canvas
24 x 36 inches

*The American Scene painters of the 1930s turned
away from impressionist techniques in favor of a
bolder style utilizing broad, flat shapes of light and
dark. Craig's stark Depression-era farm scene, with
the horse-drawn plow stirring up dust, may be
compared to William Griffith's* Harvesting Beans,
Irvine Ranch *of 1931. (page 8)*

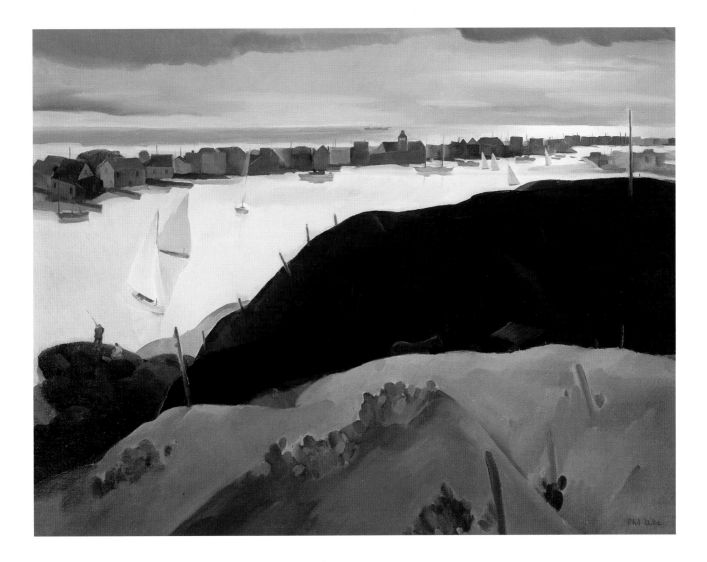

PHIL DIKE
Corona del Mar, aka *Newport Harbor*, c. 1932
Oil on canvas
23¹/₂ x 29¹/₂ inches

This is one of the earliest of Phil Dike's series of paintings of Newport Harbor, a subject which would occupy his interest for nearly all of his career. Typical of his style in the early 1930s, it shows his penchant for shape and form, contrasts of dark and light, and bird's-eye perspective.

dazzling verisimilitude to an expressiveness bordering on abstraction in which he built up the rugged forms of the mountains with broad slabs of paint, wielding his brush like a sculptor.

Such adventures defined these artists as true disciples of the plein air school. Antony Anderson described Anna Hills' plein air style: "To catch this transitory pictorial beauty is her aim, and therefore, her sketches are made rapidly, through only one of nature's moods. She never returns to 'fix up' her sketch."[11] Often such sketches made on location were later transferred to a larger canvas in the studio. However, many artists executed large-scale, finished paintings on the spot. Anderson noted that William Wendt, while working in Topanga Canyon in 1909, completed paintings on 28 x 36 inch canvas out of doors from "start to finish." Such a method, Anderson noted, "leads to truth of statement and sincerity of expression; things are tangible and real, though made exquisite by the mood that dominated the painter when he looked at them."[12]

It is the subtle mood of many of the Southern California works which imbues them with a special beauty. The appreciation by the artists for the wonders of nature is evident. San Diego artist Maurice Braun's work are impacted with his religious beliefs, rooted in Theosophical ideas. They have a wonderful quality of vibratory light and color—a direct result of impressionist strategies—which also conforms to Theosophical tenets.

Like the work of Guy Rose and Alson Clark, Braun's work is more closely aligned with Impressionism in its French form because of the high-key palette. Nevertheless, in their California works, color is richer and sharper. It is, indeed, in the less naturalistic use of color, the simplification of form, and an emphasis on the decorative that distinguishes many Southern California artists who are called Impressionists. Such distinctions derive more from the postimpressionist aesthetic. Examples may be seen in the work of San Diego artist Charles Reiffel and in the later work of Franz Bischoff. Reiffel employed an energetic, sinewy line and bold coloration which resulted in highly unique and expressive works. Bischoff was a noted ceramic decorator, born and educated in Austria, who did not take up panel painting until after his move to California in 1906. Many of his early works exhibit the soft tonality and feathery brushwork of Impressionism; but in his later works, after 1915, the color is rich and strong, stretching the limits of naturalism. Bischoff also had a particularly unique way of applying his pigment—a kind of "laying-in" of the color, evidence of his ceramicist background. In addition, like in the later works of William Wendt, the solidity of the forms brings to mind the work of Cézanne.

Rich, voluptuous color was also used by the Hungarian-born Joseph Kleitsch, who had been primarily a portrait and figure painter in Chicago before he settled

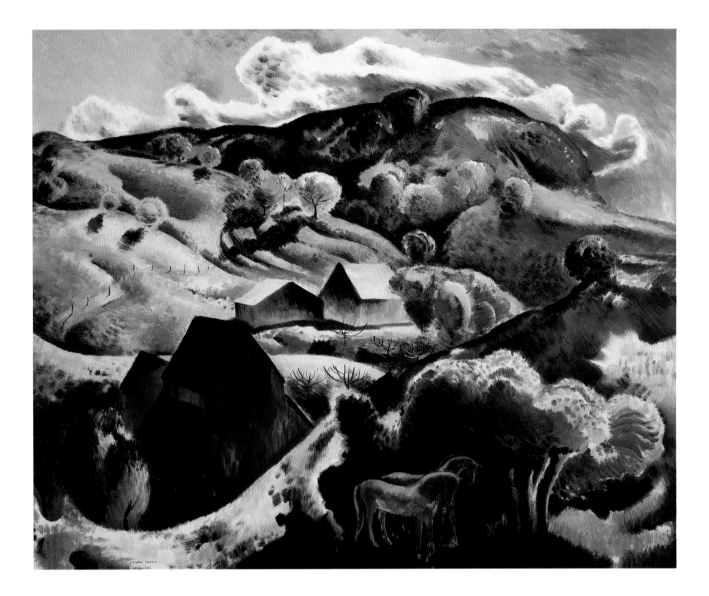

MILLARD SHEETS
Birth of Spring, 1937
Oil on canvas
30 x 36 inches

Acquired by the Metropolitan Museum of Art in 1939, this lyrical painting, made at the pinnacle of Sheets's career, reflects his love of life in California—the land, the farms, and the horses as symbols of all that is living. Its undulating, rhythmic design, and bold pattern gives a vigorous life to the land. The hills seem to take on an anthropomorphic quality, characteristic of many of the artist's paintings of the California hills. The painting was deaccessioned by the Met in 1990.

in Laguna Beach in the winter of 1920. Although he continued to do portraiture, lured by the charms of that quaint and picturesque environment, he too began recording the landscape. He also made a conscious decision to record the allure of the then-rustic village of Laguna Beach, knowing that soon its idyllic and unspoiled character would succumb to a building boom brought in by real estate developers. Paintings by Kleitsch are sensuous in their brilliant color and bravura brushwork. Anderson commented: "Kleitsch paints the facts of light, color and form with a superb and easy gesture. . . . His portraits have the vigor of life itself . . . with the added touch that spells mystery, beauty and poetic feeling."[13] One of his most charming pictures is *Enchantment*, 1922, an intimate view of his young wife cooling her feet in a mountain pool.

The coastal areas and the sea in its many moods were another favorite subject for the Southern California painters. Whether at sunrise or sunset, storm-tossed or still, the waters of the Pacific illuminated by the brilliant California light, were ideal for interpretation. Painters primarily known for their landscapes—William Wendt, Franz Bischoff, Edgar Payne, Jack Wilkinson Smith, Maurice Braun, and Alson Clark—occasionally exhibited seascapes as well. Frank Cuprien, who established a studio in Laguna Beach in 1914, became a master of the seascape, emphasizing the play of sunlight and moonlight on a calm, serene sea, as in *An Evening Symphony*.

It was natural that in painting the Southern California landscape, artists were drawn to the proliferation of wild flowers, such as poppies and lupines, that carpeted the countryside beginning in early spring. Paintings like Benjamin Brown's *Poppies Near Pasadena*, John Gamble's *Joyous Spring*, and Granville Redmond's *Southern California Hills*, were sought after by Eastern art dealers whose patrons wanted paintings of nature's riches in California. Artists were also drawn to the intimacy and multihued motifs of the flower garden as seen in Brown's *The Joyous Garden*, a painting which has a strong affinity with Eastern orthodox Impressionism. The intimacy of the garden is also seen Gardner Symons' painting of his Laguna cottage, as well as in Franz Bischoff's flower paintings, such as the still life *Roses*, and in the floral studies of Donna Schuster.

Such paintings, especially those depicting wildflowers, became the subject matter for many amateur artists who came to California in the 1920s and 1930s. The proliferation of painters who rapidly produced paintings for eager tourists elicited harsh criticism from the press. In 1928 Merle Armitage wrote a satirical article in the *West Coaster*, accusing nine-tenths of the artists on the West Coast of grinding out repetitive calendar illustrations. He classified those so-called artists as the "eucalyptus school" of painting,[14] a phrase which, unfortunately, became an accepted term for all the Impressionist artists, including the serious, professional, and highly respected painters who had arrived in California early in the century.

By 1930 interest in pure landscape painting was waning and Impressionism was in decline. Modernist ideas, which had initially met with strong resistance from traditional circles, slowly began eroding traditional, conservative theories. Arthur Millier, who had replaced Antony Anderson as art critic for the *Los Angeles Times* in 1926, was more receptive to modernist ideas, and he called for less "pretty picture[s]," more "penetrating comments on our life and people," including a more expressive interpretation of the landscape.[15] With the beginning of the Great Depression, America became more insular. This was reflected by artists who incorporated a heightened sense of social consciousness in their work, depicting regional portraits of the land and man's relation to it.

In California, especially in the South, this new generation of artists continued to view the landscape as a source of inspiration. Many had studied under the older artists and briefly worked in an impressionist style. However by about 1932 artists such as Millard Sheets, Tom Craig, Phil Dike, Rex Brandt (b. 1914), Emil J. Kosa, Jr. (1903–1968), Phil Paradise (b. 1905), and Barse Miller (1904–1973), abandoned impressionist techniques and began to create works with bold forms and dramatic contrasts of dark and light.

NOTES

1. Michael Williams, "The Pageant of California Art," in *Art in California* (San Francisco: R. L. Bernier, 1916), 62.

2. William Howe Downes, "California for the Landscape Painter," *American Magazine of Art* 11 (December 1920): 491.

3. *Los Angeles Times*, 11 August 1929.

4. *Los Angeles Times*, 19 November 1916.

5. Mabel Urmy Seares, "Modern Art and Southern California," *American Magazine of Art* 9 (December 1917): 58.

6. Mabel Urmy Seares, "A California School of Painters," *California Southland*, February 1921.

7. *Los Angeles Times*, 21 March 1909.

8. *Los Angeles Times*, 7 July 1912.

9. *Los Angeles Times*, 5 October 1913.

10. *Conrad Buff*, transcript of interview conducted in 1964 (Los Angeles: Oral History Program, University of California, Los Angeles, 1968): 109–121.

11. *Los Angeles Times*, 16 November 1913.

12. *Los Angeles Times*, 18 July 1909.

13. *Los Angeles Times*, 20 January 1924.

14. *West Coaster* 1 (September 1, 1928). See also *Los Angeles Times*, 16 September 1928.

15. *Los Angeles Times*, 27 November 1927.

Plein Air Painting
in Northern California

BY Harvey L. Jones

CALIFORNIA HAS BEEN CONTRIBUTING to the history of American painting for at least as long as it has been a state. Notwithstanding the Native American artisans, and the illustrators who accompanied the European explorers, or the importation of religious artifacts during the Spanish period, California's visual arts tradition in painting really began with the 1849 Gold Rush.

A number of well-trained professional artists were among the hoards of gold seekers who arrived in San Francisco on their way to the gold fields. When their dreams of finding a fortune in gold failed to materialize, some of them found success as portrait painters to a patronage of those more fortunate. This pioneer group of painters included Thomas Ayres (1816–1858), William Smith Jewett (1812–1873), Ernest Narjot (1826–1898), Charles Christian Nahl (1818–1878), and Hugo Wilhelm Arthur Nahl (1833–1889), who were among the first to depict scenes of early California.

Soon, in the 1860s, another influx of accomplished painters came to Northern California from Europe or the American East in pursuit of new subjects for their popular landscape paintings. News spread of the spectacular scenery along the rocky Pacific Coastline with its groves of giant redwood trees, or to Mt. Shasta to the north, Yosemite Valley and the Sierra Nevada Range to the east, all of which offered new pictorial opportunities to painters of romantic landscapes. The artist's efforts to capture on canvas the rapidly vanishing wilderness of America's last frontier resulted in the awe inspiring panoramas of majesty and grandeur seen in works by Albert Bierstadt (1830–1902), Thomas Moran (1837–1926), Thomas Hill (1829–1908), and William Keith (1838–1911), among others.

WILLIAM RITSCHEL,
Purple Tide (detail)

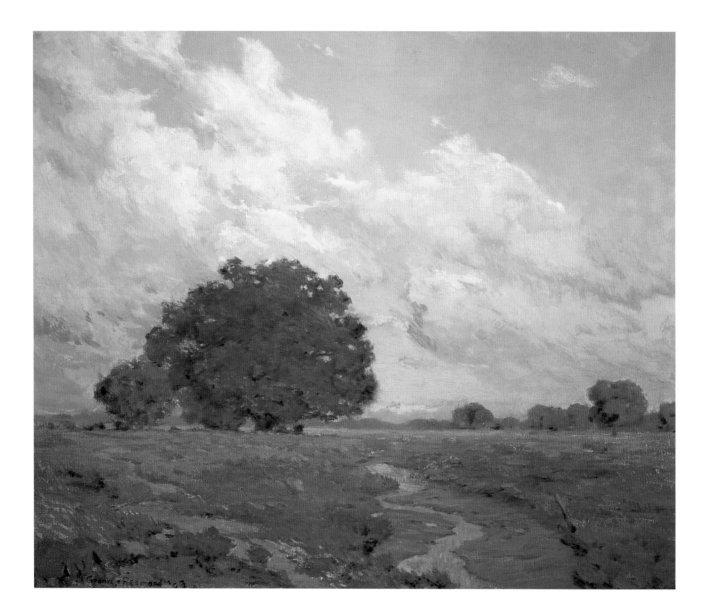

GRANVILLE REDMOND
Trees by a Meadow Stream, 1909
Oil on canvas
22 x 26 inches

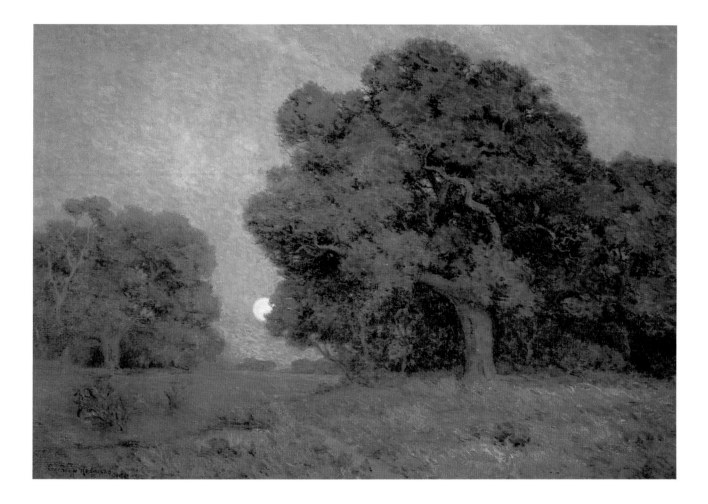

Granville Redmond
California Oaks, 1910
Oil on canvas
30 x 42 inches

"Mastery of the close color harmonies of a tonal palette suited the evocative moonlit nocturnes and ethereal, atmospheric scenes Redmond favored. Avoiding the strong contrast of light and shadow, the tonal painting is executed in subtle gradations of a dominant hue in a low key such as gray or brown." —Harvey L. Jones, 1988

California soon acquired a community of resident and itinerant painters who maintained studios in San Francisco, the state's center of artistic pursuits during the second half of the nineteenth century. In their studios the painters were able to bring to convincing realization the splendors of the California landscape based upon many small sketches made during field trips. San Francisco developed an active art press that reported on the activities of the artists and their exhibitions at a growing number of art galleries. The cultural aspirations of the city's wealthiest and most socially prominent citizens created an important patronage for the artists. The demand for formal portraiture and the popularity of California landscapes would continue the good fortune of San Francisco's prosperous art community until the economic decline of the 1880s, when the artistic taste of the patronage shifted toward collecting European art.

By 1871 a group of painters and art patrons founded the San Francisco Art Association to provide for regular public exhibitions of art. Three years later the Art Association established its own California School of Design, the first academy of art west of Chicago. Virgil Williams (1830–1886), who was born in Maine and received his art training in New York and Rome, was hired as the first director of the school. Most of Williams' own paintings reflected the subjects and style of art that he observed during his studies in Italy, along with a few portraits and, on rare occasions, a California landscape. Virgil Williams' *Landscape with Indians,* from The Irvine Museum collection, represents a departure in both subject and style from his typical scenes of Italian peasant life favored by local collectors of European painting. His subject is drawn from life on the American frontier and rendered in a style reminiscent of the American Luminist tradition in the East.

Under Williams' leadership the California School of Design provided its students with sound basic academic art training by a faculty of some of the best painters in the West. Originally located in spaces on the second floor of a storefront building on Pine Street, it later moved to the Nob Hill mansion donated by the widow of Mark Hopkins where it became known as the Mark Hopkins Institute of Art. A number of the state's first generation of native-born artists were included among the early graduates of the School of Design.

The school's curriculum was modeled on that of the French École des Beaux-Arts in Paris where emphasis was placed on mastery of basic drawing skills that included sketching from plaster casts of antique Greek and Italian Renaissance sculptures from the Louvre. Enrollment of women often outnumbered that of men at the school.

In 1890 Arthur Mathews (1860–1945) was appointed Director of the School of Design where he implemented reforms in the curriculum that included de-emphasis of "antique" classes in favor of "life" drawing from nude or draped models

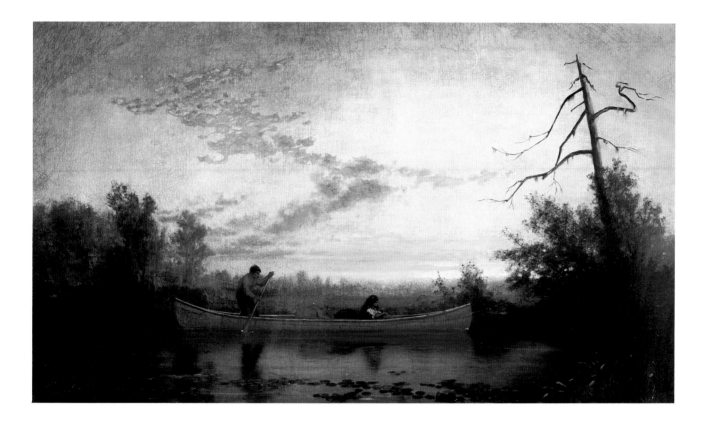

VIRGIL WILLIAMS
Landscape with Indians, c. 1875–80
Oil on canvas
18 x 30 inches

The majority of Williams' work pertains to European subjects. Landscape with Indians *is one of his few paintings relating to California. Painted sometime in the 1870s, it is handled in the dark tones and meticulous academic technique that typified the pre-Impressionist epoch.*

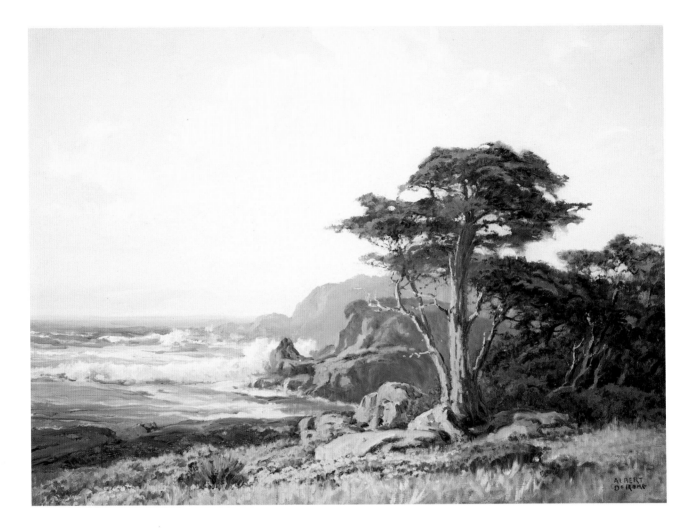

ALBERT DeROME
Old Seventeen Mile Road, n.d.
Oil on board
18 x 24 inches

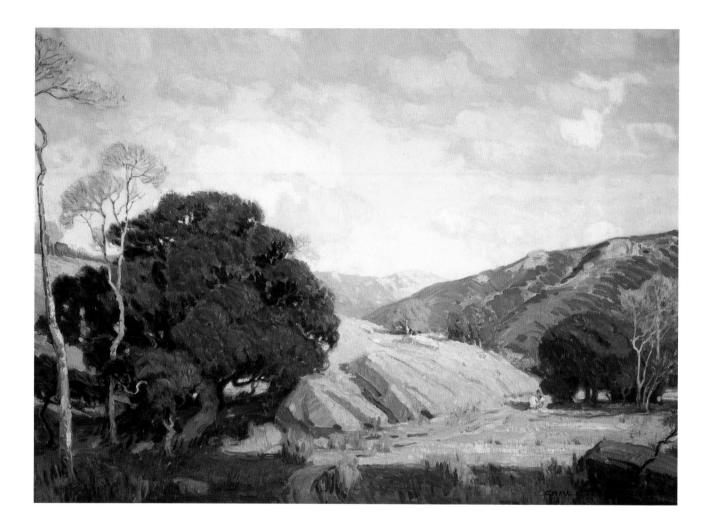

CARL OSCAR BORG
Valley Oaks, n.d.
Oil on canvas
30 x 40 inches

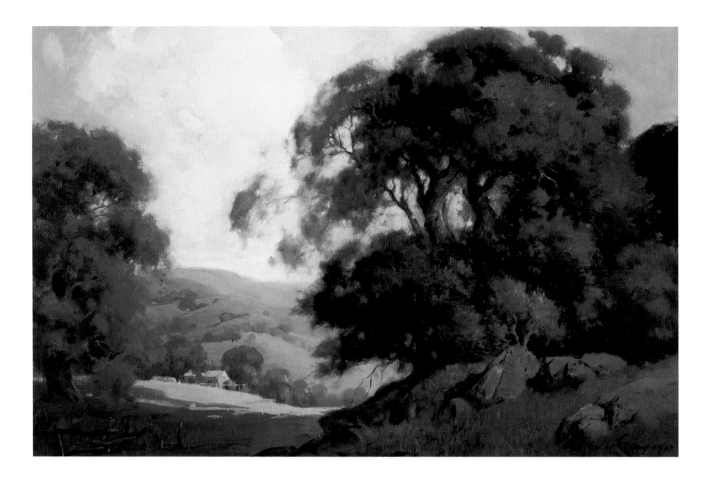

Percy Gray
California Landscape, 1918
Oil on canvas
19 x 28 inches

Percy Gray once remarked that he was not so much painting the scene as he was painting the atmosphere. Characteristic of this early work is the dominant tree in the foreground. The feel and tone recalls the Barbizon school and the work of Corot.

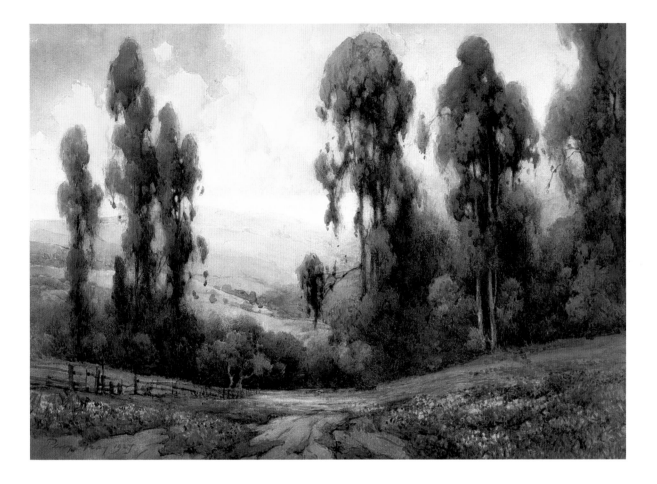

PERCY GRAY
Path to the Blue Mountains, 1927
Watercolor on paper
Sight 19¹/₄ x 27 inches

Gray gained fame as a master of lyrical works in watercolor which depicted the California countryside in the area near San Francisco. Their style and technique are representative of traditional English watercolor methods which utilized delicately applied transparent washes to define the forms. The expansive vista, looking down into the scene, is characteristic of Gray's later works.

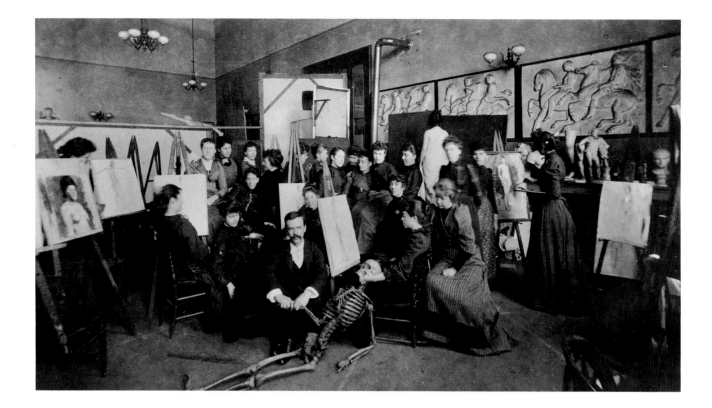

Arthur Mathews with women's life class, California School of Design, c. 1893.

in the gender-segregated classes. Mathews, whose own art training was at Académie Julian in Paris, encouraged his pupils toward further study in Europe.

The proud roster of prominent California artists who studied at the School of Design or the Mark Hopkins Institute include Percy Gray, Armin Hansen, Guy Rose, E. Charlton Fortune, Granville Redmond, and Albert DeRome, all of whom remained active in Northern California and are represented in the collection of The Irvine Museum.

By the 1890s, when the first of the California-schooled artists began to receive recognition and gain confidence in their own work, the prevailing style of American painting was changing. George Inness (1825–1894) was America's most respected landscape painter at the time of his influential visit to California in 1891. William Keith, California's own old master painter of landscapes, was a great admirer of Inness with whom he shared the philosophical ideal that the painter should strive to synthesize the poetry of nature with objective fact.

A new emphasis on art for art's sake reflected a greater sophistication in the works of painters who had been exposed to new European trends. The Barbizon group of artists in France had already been painting *en plein air*, working out of doors in direct observation of nature to render scenes in spontaneous brushstrokes on the canvas without benefit of elaborate preliminary sketches. The choice of

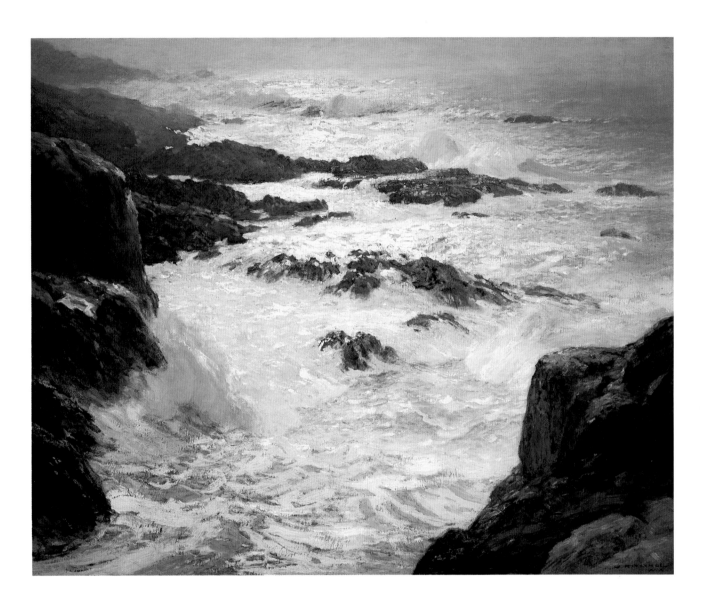

WILLIAM RITSCHEL
Our Dream Coast of Monterey, aka *Glorious Pacific,* n.d.
Oil on canvas
50 x 60 inches

"Few living marine painters know the sea as Ritschel does . . . when he paints a fine marine you feel in it the beauty and the danger, the cruel, barren ocean-love which will not release the enthralled painter." —Antony Anderson, 1924

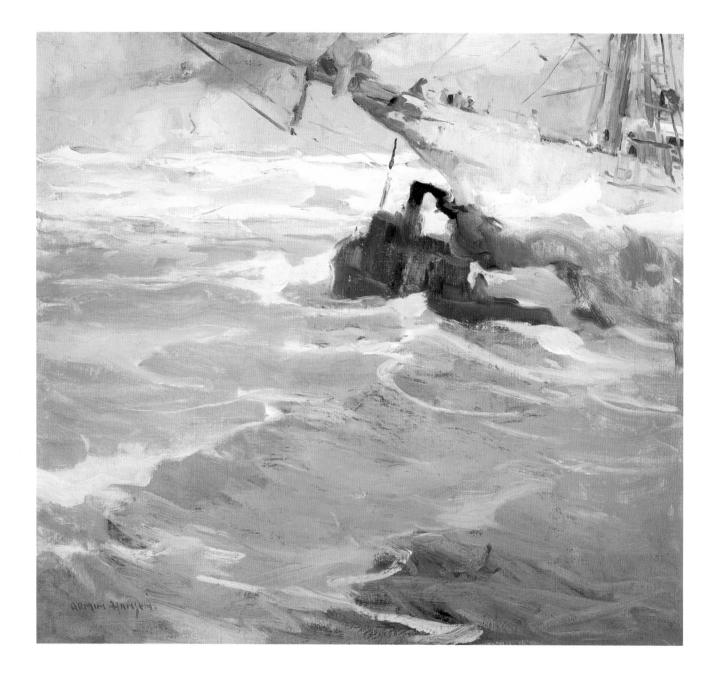

ARMIN HANSEN
Making Port, n.d.
Oil on canvas
30 x 32 inches

As a young man Armin Hansen worked as a seaman in the North Sea, and his fascination with the sea is often seen in his work. The turbulent composition of Making Port *effectively conveys the sensation of rough seas, with the tug tossed about in its efforts to meet the incoming ship.*

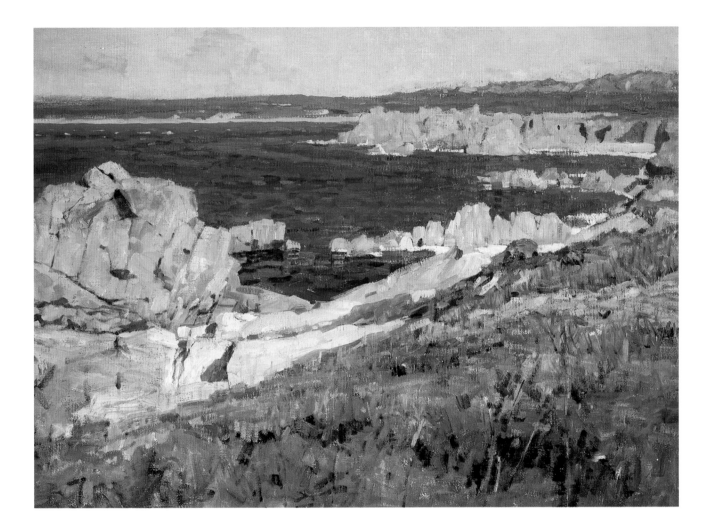

BRUCE NELSON
The Summer Sea, c. 1915
Oil on canvas
30 x 40 inches

Exhibited in 1915 at the Panama-Pacific International Exposition in San Francisco, The Summer Sea *was awarded a silver medal. Bruce Nelson received high praise for his work, yet there are no exhibition records or criticisms of his work after 1924. It remains a mystery as to why such a talented artist seemed to end his career after such a brief period.*

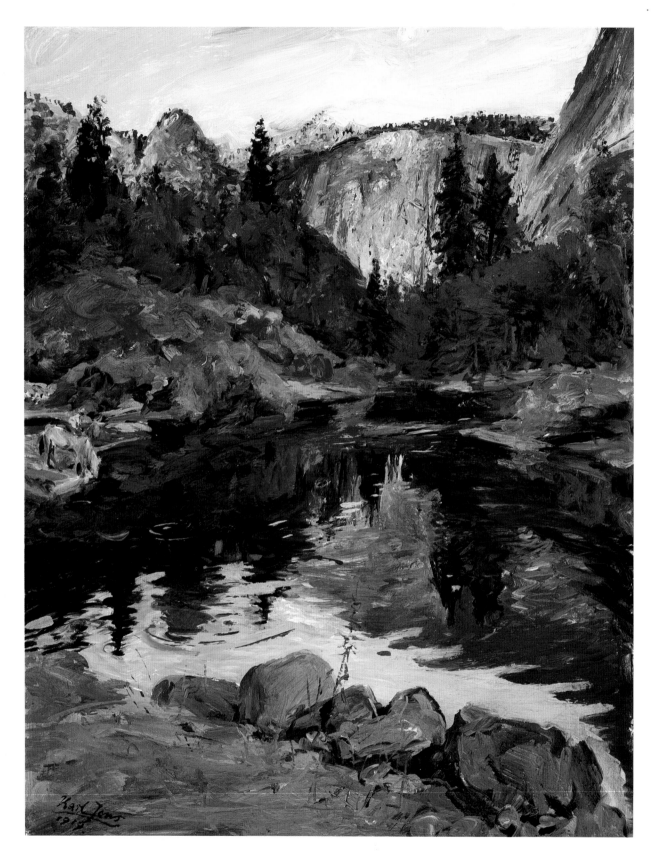

KARL YENS
Yosemite, 1919
Oil on board
24 x 18 inches

Yosemite with its breathtaking beauty was a favorite painting spot for artists who came to California beginning with the Romantic Realists of the nineteenth century such as Thomas Hill (1829–1908) and Albert Bierstadt (1830–1902).

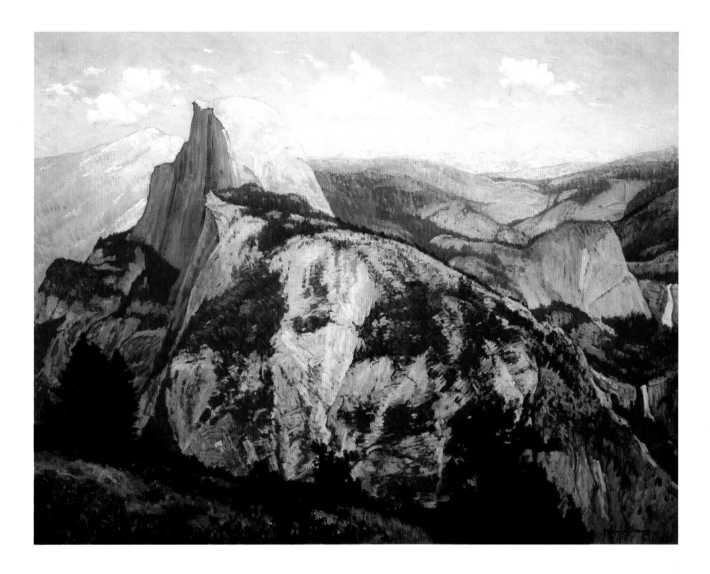

MAURICE BRAUN
Yosemite, Evening from Glacier Point, c. 1918
Oil on canvas
40 x 50 inches

Outdoor painting class,
Newport Bay, c. 1930.

modest domestic subjects on an intimate scale was in contrast to the grand panoramas of an earlier style. American painters were turning away from the crisply defined descriptive realism of an Albert Bierstadt toward more subjective interpretations realized through an aesthetic style that has been termed Tonalism. This was a challenging vanguard approach to painting that not only superceded the popularity of realism, but one which also rejected the tenets of plein air painting inspired by French Impressionism. Nature remained the principal inspiration for Tonalism, particularly in landscape painting. The artists explored the quiet contemplative moods of nature experienced in the diminished light of early morning, late afternoon or evening. These often mysterious or romantic lighting effects were achieved through representations of atmospheric fog, mist, or haze rendered in carefully controlled low-key color harmonies that seemed to envelope the subject, to soften or blur the imagery, leaving all other details to the poetic imagination of the observer.

Northern California provided two crucially important prospects for a regional impact on the style: first, the artistic influences of two major American painters, George Inness and James Abbott McNeill Whistler (1834–1903), conveyed through the art and teachings of two of California's leading artists of the time, William Keith and Arthur Mathews; second, the prevailing natural atmospheric conditions that produced the fog and haze characteristic of coastal California, most significantly around the art centers of San Francisco Bay and Carmel/Monterey.

The lessons of Whistler's carefully organized compositions, arranged in a

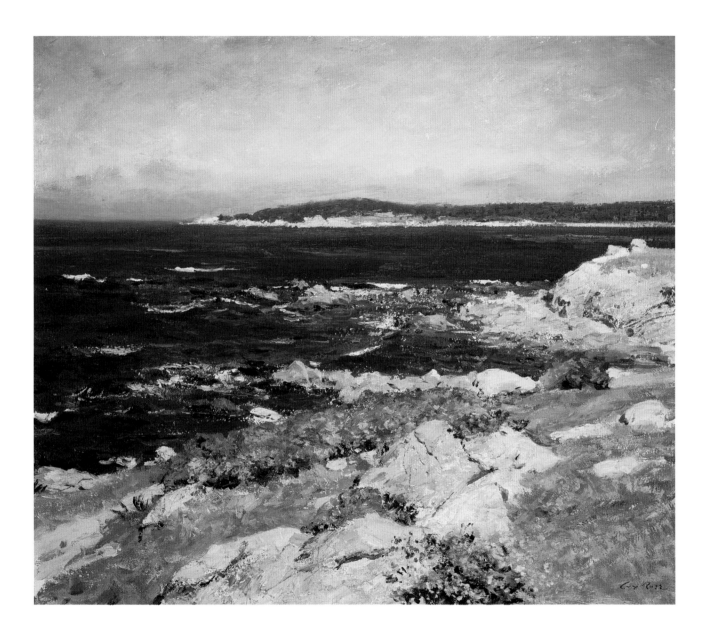

GUY ROSE
Carmel Seascape, c. 1918
Oil on canvas
21 x 24 inches

Between 1914, when he returned to California, and 1921, when he suffered a stroke and could no longer paint, Guy Rose was a ceaseless traveler. He painted a series of remarkable canvases in various locales in California from San Diego to Carmel, including La Jolla, Catalina, Laguna Beach, Los Angeles, Monterey, and in the High Sierras.

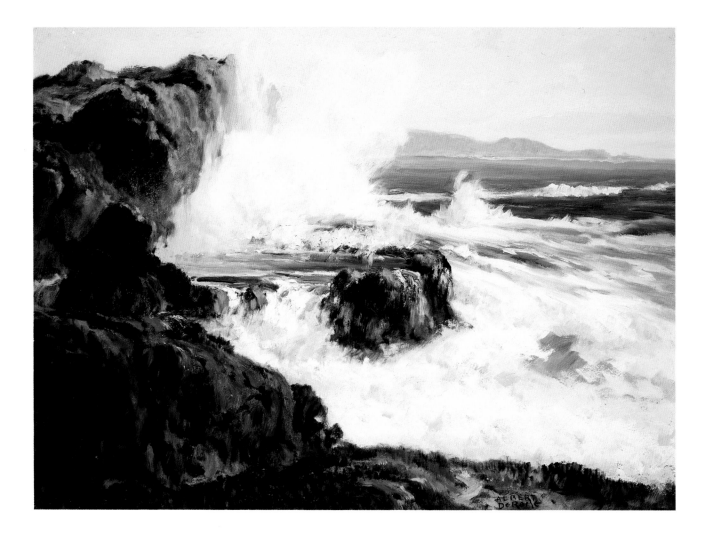

ALBERT DeROME
South Shore, Point Lobos, n.d.
Oil on board
18 x 24 inches

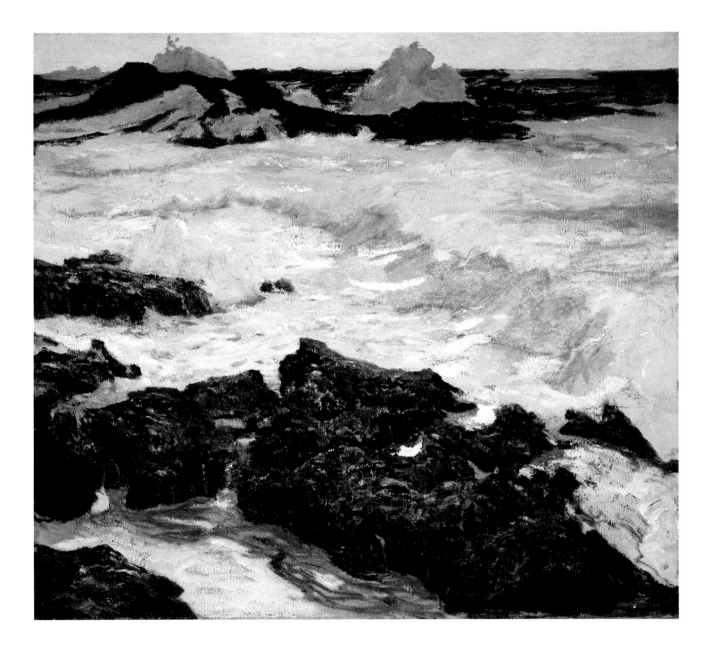

WILLIAM RITSCHEL
Purple Tide, c. 1915
Oil on canvas
36 x 40 inches

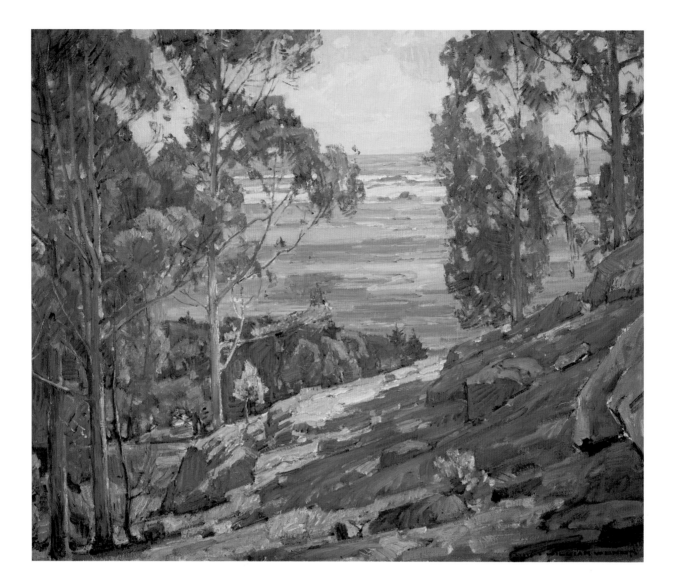

WILLIAM WENDT
Eucalyptus Trees and Bay, 1930
Oil on canvas
30 x 36 inches

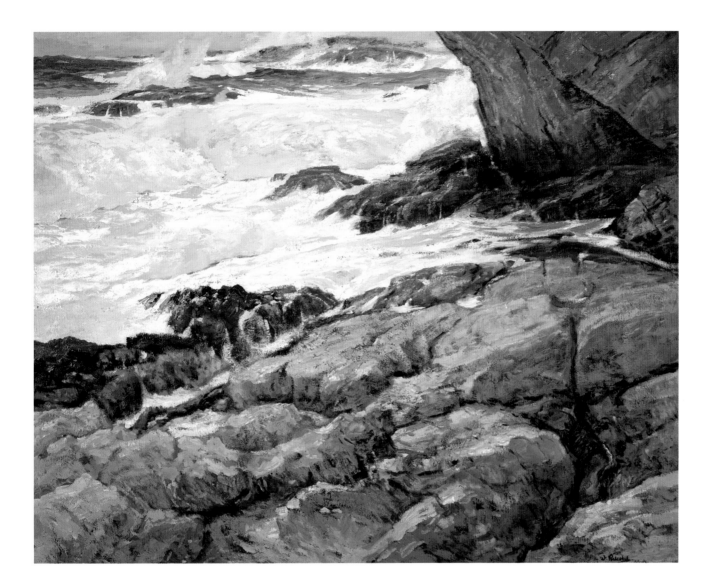

WILLIAM RITSCHEL
No Man's Land, aka *'Dat Devil Sea,* c. 1931
Oil on canvas
50 x 60 inches

The strength and power seen in this dramatic work break the bounds of traditional Impressionism. The foreground area dominates the picture plane, revealing the artist's keen sense of composition and design and his ability to interpret the scene in a unique way.

subdued palette of grayed tones, were embraced by San Francisco's dominant artistic influence of the period, Arthur Mathews. His own form of decorative tonalism, now referred to as the California Decorative Style, merges his academic figurative training with a Whistlerian color harmony.

Arthur Mathews was a major figure in the artistic life of San Francisco during the period around the turn of the twentieth century. As a prominent muralist, easel painter, designer, architect, teacher, art jurist, writer, and civic arts advocate, he embodied the concept of a Renaissance man in the arts more than any other artist in California. It is arguable that Mathews' personal rejection of the tenets of French Impressionism influenced a generation of California painters resulting in the delayed impact that the once vanguard style had on the plein air painters of California. Most of his successful students, who included his wife Lucia Kleinhans Mathews (1870–1955), Gottardo Piazzoni (1872–1945), Xavier Martinez, (1869–1943), Guiseppe Cadenasso (1858–1918), Francis McComas (1875–1938), and Granville Redmond, received the influences of Tonalism through Arthur Mathews.

After the great earthquake and fire of 1906, San Francisco's visual arts heritage from the nineteenth century suffered a devastating loss which could never be fully recovered. Important private collections of precious California paintings perished in the flames that also virtually took the life's work of several artists whose homes and studios were burned. For several years during the rebuilding of the city, the center of artistic life shifted to the Monterey Peninsula where many painters opened studios in Carmel, Pacific Grove, or Monterey. Other San Francisco artists moved to the East Bay cities of Oakland, Alameda, or Berkeley where some remained permanently.

The Monterey area, with its historic missions and adobe ruins, offered breathtaking beauty in natural surroundings that also included a deep blue crescent bay, sandy beaches and windswept rocky promontories on which grew the gnarled-trunk cypress trees, tall graceful Monterey pines, and the intensely magenta blossomed ice plants. The Carmel Valley provided sunny vistas of rolling hills robed in the greens or golds of its seasons.

Several artists had maintained summer studios on the Monterey Peninsula since the 1890s, but after 1906 they occupied them on a permanent basis. Soon a true artists' colony, which included writers and poets, developed among refugees of the fire, and it maintained much of its artistic vigor until World War II.

The center of activity became the Hotel Del Monte Art Gallery in Monterey, which opened in 1907 with the cooperation of San Francisco's leading artists. The gallery provided the much needed place for artists to exhibit and sell their work. A virtual who's who of California painters from the first half of the twentieth century are among those who regularly worked and exhibited in Monterey. In addition to

E. Charlton Fortune
Study for Monterey Bay, c. 1914
Oil on canvas
12 x 16 inches

Plein air artists always sketch out of doors, and these field sketches commonly exhibit a liveliness and spirit often absent in the final, large-scale canvases which were frequently completed in the studio. Moreover, the quick studies reveal the candid fluency of the artist, showing pure art independent of intellect.

John Gamble
Santa Barbara Landscape, n.d.
Oil on canvas
30 x 48 inches

BENJAMIN BROWN
Autumn Glory, n.d.
Oil on canvas
28 x 36 inches

The title of this work is appropriate to the colorful, light-filled composition, an intimate view of a peaceful scene. The annotation "California" beneath the signature is the artist's "hallmark," representing his pride in being an artist from California.

most of the aforementioned Northern California painters were Carl Oscar Borg, Benjamin Brown, William Wendt, and John Gamble, who were also notably active in Santa Barbara or farther south in the state.

As the art colony's reputation grew a number of well-known Eastern painters took studios on the Monterey Peninsula. Childe Hassam (1859–1935) and William Merritt Chase (1849–1916) have left canvases that mark their visits; and New York painter and National Academician William Ritschel became a permanent resident of the Carmel Highlands where he remained a prominent painter of marine subjects. By the early teens Northern California painters had been exposed to Impressionism in France or through the numerous examples of what by then was an international style of Impressionism, exhibited in the Palace of Fine Arts at the 1915 Panama-Pacific International Exposition.

French painting by artists such as Claude Monet and Pierre-Auguste Renoir, as well as the Americans William Merritt Chase, Childe Hassam, and Frederick Frieseke (1874–1939), began to influence the painters of California. Guy Rose, Euphemia Charlton Fortune, Bruce Nelson, Percy Gray, and Albert DeRome are among painters active in Northern California who adopted the lighter palette and loose, spontaneous brushstokes of Impressionism in their landscapes painted *en plein air.*

The Impressionist-inspired landscapes of California featured typical, yet often unidentified, locales indigenous to the coastal regions of the state. Favorite scenes depicted California as a colorful sunlit garden of wildflowers or as a tranquil retreat with a quiet pool framed by the aesthetic branches of eucalyptus, Monterey cypress, or live oak trees. Much of the appeal of these scenes was that they seemed to allow the observer to imagine comfortably inhabiting a landscape of human scale quite unlike the overwhelming spectacle of nature that the wilderness represented in typical nineteenth-century California landscapes.

The ideal of painting a landscape *en plein air* directly from nature in a single sitting was not often realized in actual practice. Although the relatively small-sized canvases and the speed of painting with quick gestural brushstrokes helped to facilitate the ideal, most painters found it necessary to return to a scene more than once in order to capture the often fleeting midday lighting effects. Many a painting was completed in the artist's studio without sacrificing the requisite immediacy of execution. The plein air painters of Northern California remained active and popular until the onset of the Great Depression in the early 1930s when the art market collapsed along with everything else. At a time when many American artists were showing greater interest in Social Realist painting, to better reflect the times, there was also a younger generation of artists who chose to experiment with various vanguard approaches to painting inspired by the European Modernists.

Artists' Biographies

The following are brief biographical notes for the artists represented. More detailed information on these artists may be found in a number of other publications listed in the Selected Bibliography.

Bartlett, Dana

Born November 19, 1882 in Ionia, Michigan

Died July 3, 1957 in Los Angeles, California

First to California, c. 1914; established residence in Southern California, 1915

Dana Bartlett studied with William Merritt Chase (1849–1916) and Charles Warren Eaton (1857–1937) at the Art Students League in New York City. For a brief period he worked at the Lea Lash Art Studios before moving to Boston where he studied advertising design. He moved West, obtaining employment with the commercial firm of Foster and Kleiser in Portland, Oregon. He later moved to San Francisco, where he opened a studio and finally, late in 1915, to Los Angeles.

Bartlett was active with the California Art Club and the California Water Color Society which he helped found and served as the first president. He joined the faculty of the Chouinard School of Art in 1925, teaching commercial art. In 1928 he opened a gallery which specialized in small oil paintings, etchings, and watercolors.

Bartlett held memberships in the California Art Club, the California Water Color Society, the Decorative Art Society, the Laguna Beach Art Association, and the Painters and Sculptors Club.

Bartlett traveled extensively throughout the West. In 1924 he spent six months in Europe, studying the works of the Old Masters. He was particularly impressed by Titian, Monticelli, and Turner. He worked in oil and watercolor, and experimented with underpainting with venetian tempera.

Bischoff, Franz A.

Born January 14, 1864 in Bomen, Austria

Died February 5, 1929 in Pasadena, California

To the United States, 1885; first in California, 1900; established residence in Southern California, 1906

Franz Bischoff received early artistic training at a craft school in Bomen. In 1882 he went to Vienna for further training in painting, design, and ceramic decoration. He immigrated to the United States in 1885 and obtained employment as a china decorator in New York City. He moved to Pittsburgh, then to Fostoria, Ohio, and finally to Dearborn, Michigan, continuing to work as a ceramic decorator. One of the foremost ceramic artists of his day, he founded the Bischoff School of Ceramic Art in Detroit and another such school in New York City. He formulated and manufactured many of his own colors, participated in exhibitions and won awards, earning a reputation as "King of the Rose Painters."

He first visited California in 1900 and, finding the climate and scenery appealing, moved his family there in 1906, settling briefly in San Francisco, then in Los Angeles. In 1908 he built a studio-home along the Arroyo Seco in South Pasadena, which included a gallery, ceramic workshop, and painting studio. In 1912 he took an extended tour of Europe where he studied the works of the Old Masters and the Impressionists.

After moving to California, Bischoff began painting on canvas in addition to continuing his ceramic work. He painted the coastal areas of Monterey and Laguna Beach, the Sierras, and the desert near Palm Springs. He also painted the harbor at San Pedro and the farms in Cambria. In 1928 he made a trip to Utah where he painted in Zion National Park. In addition he painted exquisite still lifes depicting flowers—roses, peonies, and mums.

Bischoff exhibited with the California Art Club and the Laguna Beach Art Association. In 1924 he received the Huntington Prize at the California Art Club. His ceramic works were exhibited at the 1893 World's Columbian Exposition in Chicago and at the 1904 Louisiana Purchase Exposition in St. Louis.

Borg, Carl Oscar

Born March 3, 1879, Karl Oskar Borg, in Osterbyn Ostra, Grinstads, Sweden

Died May 8, 1947, in Santa Barbara, California

To the United States, 1901; established residence in Southern California, 1903

Carl Oscar Borg began drawing at a young age, copying pictures from books. At the age of fifteen, he was apprenticed to a house painter who taught him how to mix paints and create decorative wall motifs which were popular at that time in Sweden. In the spring of 1899 he traveled to Stockholm and gained employment with a ship painting firm. He went to France, remaining briefly before going on to London where he found a position with George Johansen, a portrait and marine painter. He tinted photographs and began to paint landscapes.

In April 1901 Borg sailed for the United States. He traveled throughout the East and in Canada, working occasionally as a house painter and furniture painter. In 1903 he settled in Los Angeles and found work with a Danish photographer. He established himself in the art world, becoming a close friend to Idah Meacham Strobridge, owner of the gallery The Little Corner of Local Art, and George Lummis, editor of *Out West* magazine. Lummis encouraged Borg's interest in the American Indians of the Southwest.

Borg found financial support from wealthy art patrons Mary Gibson, who sponsored Borg's painting trip to Central America in 1908, and Phoebe Apperson Hearst, mother of William Randolph Hearst. Hearst became his most important benefactor, providing him with financial backing for many years. In 1910 she sponsored his four-year sojourn in Europe, where he painted in Spain, Italy, France, Switzerland, Holland, Belgium, Sweden, and Egypt. He received adulation from the French press when a one-man show was held for him at the Jules Gautier Galerie in 1913.

With the outbreak of World War I, Borg returned to San Francisco and opened a studio. In 1916, again with sponsorship from Hearst, he began a lifelong project of painting and photographing the Southwest desert and its native people. Every spring for the next fifteen years, Borg would live with the Hopi and the Navajo. Borg recognized that these native Americans were being assimilated into Western culture, and his paintings are inspiring in their celebration of the spirit of the Indians and the West.

From 1918 to 1924 Borg lived in Santa Barbara, then moved to Los Angeles where he had a studio-home in Hollywood. He obtained work as an art director and set designer and also did illustrations for books and magazines.

Depressed over personal problems and the decline of popularity for his style of art, Borg left California in 1936 and moved to New York. For the next few years he divided his time between New York, Sweden, and California, where he spent winters. He finally settled in Santa Barbara for the last time in the fall of 1945.

Borg held memberships in the California Art Club, Academy of Western Painters, Laguna Beach Art Association, Painters of the West, Printmakers Society of California, Salmagundi Club, San Francisco Art Club, and the National Academy of Design, to which he was elected in 1938. His awards included a silver medal, Panama-Pacific International Exposition, San Francisco, 1915; gold medal, Panama-California International Exposition, San Diego, 1916; a silver medal, Société des Artistes Français, 1920; Paul R. Mabury Purchase Prize, California Art Club, 1920; Huntington Prize, California Art Club, 1923; silver medal, Pacific Southwest Exposition, 1928; and a gold medal, Painters of the West, Los Angeles, 1928.

Botke, Jessie Arms

Born May 27, 1883 in Chicago, Illinois

Died October 2, 1971 in Santa Paula, California

First to California, 1914; established residence in Northern California, 1918; to Southern California, 1927

Jessie Arms attended the Art Institute of Chicago beginning in 1902 and later spent one summer studying with Charles Woodbury (1864–1940) in Ogunquit, Maine. Moving to New York City in 1911, she worked at Herter Looms, preparing tapestry cartoons under the guidance of Albert Herter (1871–1950). She developed a special talent for depicting birds and assisted Herter with a mural for the St. Francis Hotel in San Francisco.

In 1914 the artist traveled to Santa Barbara to assist Herter's wife, Adele, with the decoration of a private home. On a brief stopover in Chicago, she met the Dutch-born artist Cornelis Botke (1887–1954). They were married in 1915 in Leonia, New Jersey.

Botke and her husband then moved to Chicago where they collaborated on two major mural commissions: one for the Kellogg Company; the other for Noyes Hall at the University of Chicago. They visited California in 1918 and moved there the following year, settling in Carmel. From 1923 to 1925 they traveled throughout Europe. In 1927 they moved to the southern part of the state, living in Wheeler Canyon near Santa Paula.

Botke was not a plein air painter, but instead focused on decorative paintings of birds, both domestic and exotic. She worked in oil, watercolor, or gouache, and often employed gold leaf in the background. Her paintings were widely exhibited both in the West and in the East.

Botke was a member of the California Art Club, the California Water Color Society, the National Association of Women Artists, the Chicago Galleries Association, and the Foundation of Western Art. Her many awards included the Martin B. Cahn Prize, Art Institute of Chicago, 1918; the Shaffer Prize, Art Institute of Chicago, 1926; and the Carpenter Prize, Chicago Society for Sanity in Art, 1938.

Brandriff, George Kennedy

Born February 13, 1890 in Millville, New Jersey

Died August 14, 1936 in Laguna Beach, California

Established residence in Southern California, 1913

George Brandriff had no formal art

training although his interest in art began in childhood where he received encouragement from his uncle, William Kennedy, a watercolorist. He held a brief career as a piano salesman both in his hometown and in California where he moved in 1913. A year later he enrolled in the College of Dentistry at the University of Southern California. In 1918 he opened a practice in dentistry in Hemet.

He enjoyed painting in his free time and took lessons from Anna Hills and Carl Oscar Borg in Laguna Beach and also studied on weekends with Jack Wilkinson Smith beginning in 1923. He also developed friendships with and received criticism from artists Edgar and Elsie Payne, Hanson Puthuff, William Wendt, Arthur Hill Gilbert, Clarence Hinkle, and William Griffith

He built a studio in Laguna Beach in 1927. A year later he closed his practice and moved to Laguna to become a full-time, professional painter. His subjects included landscapes, seascapes, still lifes, figure studies, and harbor scenes. He painted in California, Arizona, and in Europe, which he visited in 1929.

Brandriff was an active member of the California Art Club and the Painters of the West beginning in 1925. He also served as president of the Laguna Beach Art Association from 1934 until his death by suicide in 1936. During his brief career he garnered a number of awards, including a silver medal from the Painters of the West in 1929 and second prize from the California State Fair in 1930.

Braun, Maurice

Born October 1, 1877 in Nagy, Bittse, Hungary

Died November 7, 1941 in San Diego, California

To the United States, 1881; established residence in Southern California, 1910

Maurice Braun immigrated to the United States with his family when the artist was four years of age. A precocious talent, he copied works of art at the Metropolitan Museum and, in 1897, enrolled in the National Academy of Design. He spent three years there and then studied under William Merritt Chase (1849–1916) for an additional year. In 1902 he went to Europe, visiting Austria, Germany, and Hungary, the country of his birth.

Returning to New York in 1903, he soon earned a reputation as a figure and portrait painter. However, his interest in landscape painting led him to a decision to move to California. In 1910 he opened a studio on Point Loma in San Diego. He became an active member of the art community and founded the San Diego Academy of Art in 1912. One of his most important pupils was Alfred R. Mitchell. Braun was also active in art circles in San Francisco and Los Angeles, exhibiting with the California Art Club, at Kanst Galleries, and with the Laguna Beach Art Association.

In 1921 Braun returned to the East and established studios in New York City, Silvermine, Connecticut, and, finally, in the art colony in Old Lyme. After a few years he returned to San Diego, but continued from 1924 to 1929 to spend part of each year in the East. In 1929 he joined nine other artists in forming the Contemporary Artists of San Diego.

Braun was affiliated with the Theosophical Society whose tenets included transcendentalism and speculation on man, God, and the universe. Theosophy had a profound influence on his art. His paintings were expressions of nature's moods, rather than purely descriptions of the landscape.

Braun enjoyed a national reputation, and his paintings were exhibited in Chicago, Philadelphia, Pittsburgh, and New York. A one-man show was held at Milch Galleries in New York City in 1915, the same year that he received a gold medal at the Panama-California Exposition in San Diego. Other prizes included the Hallgarten Prize from the National Academy of Design in 1900 and a purchase award from the Witte Memorial Museum in San Antonio, Texas, in 1929.

Brown, Benjamin Chambers

Born July 14, 1865 in Marion, Arkansas

Died January 19, 1942 in Pasadena, California

First to California, 1886; established residence in Southern California, 1896

Benjamin Brown studied at the St. Louis School of Fine Arts. In 1886 he made a trip to California with his parents who were considering moving to Pasadena. While in California he made numerous pencil sketches of landmarks. He returned to St. Louis where he continued his studies and then opened his own art school in Little Rock while specializing in portrait painting.

In 1890 Brown went to Europe with his friends, artists William A. Griffith and Edmund H. Wuerpel (1866–1958). In Paris he studied at the Académie Julian for one year. After returning to the United States, he moved to Pasadena in 1896. He continued to do portraiture, but finding few patrons for his works, began also to paint the landscape.

Brown was active with many of the developing art societies in Southern California. He was also an etcher and, along with his brother, Howell (1880–1954), founded the Print Makers Society of California, which sponsored annual international print exhibitions for many years.

An avid Impressionist, he was outspoken in his criticism of other styles of art. He had patrons both in California and in the East. Hoping to encourage more sales, one New York dealer suggested that Brown open a studio there and conceal the fact that he was from California. Brown flatly refused and defiantly began painting the word "California" beneath his signature, affirming his pride in being a Californian.

Brown was a member of the American Federation of Arts, the California Art Club, the California Society of Printmakers, and the Pasadena Society of Artists. He received numerous awards, including a bronze medal at the Portland World's Fair in 1905, a silver medal at the Seattle World's Fair in 1909, and a bronze medal for etching from the Panama-Pacific International Exposition in San Francisco in 1915.

Buff, Conrad

Born January 15, 1886 in Speicher, Switzerland

Died March 11, 1975 in Laguna Hills, California

To the United States, 1905; established residence in Southern California, 1906

Conrad Buff studied for a time in a trade school specializing in lace design.

Dissatisfied, he left the school and went to Munich where he began to paint. At the age of eighteen, he immigrated to the United States, heading west where he made a living as a sheepherder, a pastry chef, a railroad laborer, and a house painter.

In 1907 Buff went to Los Angeles where he worked various jobs at hotels. He then found a job painting houses which led him to become a contractor in the community of Eagle Rock. He continued to paint and became active in art circles, developing friendships with artists William Wendt, Jack Wilkinson Smith, Donna Schuster, Franz Bischoff, and Edgar Payne. He often took painting excursions with fellow artists.

Buff met Mary Jordon Marsh, assistant curator of art at the Los Angeles Museum of History, Science, and Art, and they were married in 1922. Together they produced thirteen children's books, which she authored and he illustrated. In researching their books, they traveled in the Southwest, to Italy, Switzerland, Japan, Guatemala, and Mexico.

Although Buff maintained friendships with many of the California Impressionist artists, stylistically his work did not conform to their tenets. Rather his highly individualistic style reflected the developments of modernism in the simplification of form and color, architectonic structure, and modified pointillist brushwork. Buff did mural commissions in the 1920s and 1930s and came to know the architects Richard Neutra and Rudolph Schindler. During the 1940s he worked as an architectural color consultant, painter, and illustrator. He traveled throughout Arizona and Utah with artists Maynard Dixon and Edith Hamlin Dixon. He painted many impressive landscapes of Bryce Canyon, Monument Valley, Zion National Park, and the High Sierras. The strength of the colors in these works, especially the intense blue of the skies, was his way of interpreting the clear, clean atmosphere of these regions.

Buff was a member of the California Art Club and received a number of awards for his work.

Chamberlin, Frank Tolles
Born March 10, 1873 in San Francisco, California

Died July 24, 1961 in Pasadena, California

Established residence in Southern California, 1919

Frank Tolles Chamberlin spent his early childhood in the Napa Valley before moving to his parent's home state of Vermont. He studied at the Wadsworth Athenaeum in Hartford, Connecticut under Dwight Tryon (1849–1925). He then worked for a period as a landscape architect and architectural draftsman. He moved to New York and enrolled at the Art Students League, studying with George de Forest Brush (1855–1941) and George Bridgman (1864–1943).

Entering a murals competition in 1908, Chamberlin won a three-year scholarship to the American Academy in Rome under the directorship of Francis Millet (1846–1912). While there he studied the fresco works of Giotto and Tintoretto. In 1912 he returned to the United States where he began a career as a teacher at the Society of Beaux-Arts Architects (after 1941, the Beaux-Arts Institute of Design). During the summers he painted in New Hampshire at the McDowell Colony. There he met painter and sculptor Katherine Beecher Stetson (1885–1979) whom he later married.

In 1919 Chamberlin decided to move to California, seeking a milder climate and less congested environment for his family. He settled in Pasadena and secured a teaching position at Otis Art Institute. At Otis he met Nelbert Chouinard (1879–1969) who persuaded him to join her faculty when she founded the Chouinard School of Art in 1921. He taught there until 1928, while also continuing to teach part time at Otis. In addition, he taught classes at the University of Southern California and privately in his studio.

In 1934, under the auspices of the Works Progress Administration, Chamberlin was commissioned to paint a large mural for the library at McKinley Junior High School in Pasadena. The project occupied him for seven years. The immense mural reflected Chamberlin's beliefs in the simplicity and balance of classical art, principles which he espoused throughout his teaching career. He had a profound influence on the next generation of artists in Southern California.

Chamberlin held memberships in the California Art Club, the California Water Color Society, the Pasadena Society of Artists, the Beaux-Arts Institute of Design, and the Print Makers Society of California. He received a number of awards for his work.

Clark, Alson Skinner
Born March 25, 1876 in Chicago, Illinois

Died March 23, 1949 in Pasadena, California

Established residence in Southern California, 1920

Alson Clark enrolled in Saturday classes at the Art Institute of Chicago in 1887 at the age of eleven. He also received private tutoring from a German painter while visiting Europe with his family a few years later. After completing his public school education, he studied at the Art Institute for several months from November 1895 through March 1896. Not satisfied with the teaching methods at the Institute, he left for New York where he enrolled in William Merritt Chase's (1849–1916) newly formed school.

Late in 1898 Clark went to Paris where he enrolled in the Académie Carmen, the atelier of James Abbott McNeill Whistler (1834–1903). He remained there for about six months. He traveled around France and to Holland and Belgium. He continued his studies in Paris at the Académie Delecluse and with Alphonse Mucha (1860–1939). In 1901 his painting *The Violinist* was accepted at the Paris Salon.

Clark returned to the United States and, early in 1902, opened a studio in Watertown, New York. He married and returned to Paris in the fall of 1902. Thereafter he and his wife divided their time between France and the United States until the outbreak of World War I. Clark exhibited at the Art Institute of Chicago which held a one-man show for him in January 1906. His works from this period—including figure works, especially studies of his wife Medora, as well as landscapes, city scenes, and interiors—reflect the influence of Whistler.

On a summer trip in France in 1907, Clark began to lighten his palette to the higher key of his first teacher, Chase. The change in his style to a stronger impressionist method was reinforced during a trip to Spain in 1909 and was

Donna Schuster
Girl with Mirror, c. 1916
Oil on canvas
26 x 20 inches

seen in his work thereafter. In October and November of 1910 he went to Giverny where he associated with Lawton Parker, an old classmate, Frederick Frieseke, and Guy Rose.

An inveterate sojourner, Clark traveled throughout Europe and the United States. In 1913, on his way to Paris, he stopped in Panama and decided to undertake the project of recording the construction of the Panama Canal. Eighteen of those paintings were exhibited at the Panama-Pacific International Exposition in 1915.

The Clarks returned to America at the outbreak of World War I. After the United States entered the war, Clark enlisted in the Navy and was sent to France to work as an aerial photographer. Clark visited California the winter of 1919, then, in January 1920, decided to remain, acquiring a home and studio along the Arroyo Seco in Pasadena. He renewed his acquaintance with Guy Rose, who had returned to California in 1914. In 1921, he joined Rose in teaching at the Stickney Memorial School of Art.

Attracted to the Southwest landscape, Clark made numerous painting trips in California and in Mexico. He sent works for exhibition to New York and Chicago, was represented by Stendahl Galleries, and also received mural commissions. He received numerous awards, including a bronze medal, St. Louis Exposition, 1904; the Martin B. Cahn Prize, Art Institute of Chicago, 1906; a bronze medal, Panama-Pacific International Exposition, 1915; the grand prize, Southwest Museum, 1923; the Huntington Prize, California Art Club, 1924; and a first prize, Pasadena Art Institute, 1933.

Cooper, Colin Campbell

Born March 8, 1856 in Philadelphia, Pennsylvania

Died November 6, 1937 in Santa Barbara, California

First to California, 1915; established residence in Southern California, 1921

Colin Campbell Cooper attended the Pennsylvania Academy of the Fine Arts beginning in 1879. In 1886 he went to Europe, first painting in Holland and Belgium before moving on to Paris. In Paris he studied at the Académie Julian,

the Académie Delecluse, and the Académie Viti.

After his return to the United States in 1895, he taught watercolor painting at the Drexel Institute in Philadelphia for three years. He returned to Europe in 1898, traveling and painting in Holland, Italy, and Spain, and developing a reputation as a painter of the great architectural treasures of Europe. He continued to be interested in the interpretation of architecture after his return to the United States in 1902, painting a series of impressionist cityscapes of New York, Philadelphia, and Chicago. Over the next several years he continued his European sojourns and in 1913 went to India.

Cooper spent the winter of 1915 in Los Angeles, and, in the spring of 1916, visited San Diego. In January 1921 he established permanent residency in Santa Barbara, and during the 1920s he served as Dean of the School of Painting at the Santa Barbara School of the Arts. He made another trip to India and visited England, France, and Spain in 1923.

Cooper was elected to the National Academy of Design in 1902, gaining National Academician status in 1912. He was also a member of the Philadelphia Watercolor Club, the American Watercolor Society, the National Arts Club, the New York Society of Painters, the New York Watercolor Club, the California Art Club, the San Diego Art Guild, and the Santa Barbara Art Club.

He won numerous awards, among them the W. T. Evans Prize, American Watercolor Society, 1903; the Seinan Prize, the Pennsylvania Academy of the Fine Arts, 1904; a silver medal, International Fine Arts Exposition, Buenos Aires, 1910; a gold medal in oils and a silver medal in watercolor, Panama-Pacific International Exposition, 1915; and the Hudnut Prize, New York Watercolor Club, 1918.

Craig, Thomas Theodore

Born June 16, 1909 in Upland, California

Died February 8, 1969 in Upland, California

Tom Craig graduated Phi Beta Kappa from Pomona College in 1934 with a degree in botany. During his years at Pomona he had become interested in art and was encouraged by Thomas Beggs, who was head of the art department.

Millard Sheets, who was at Scripps, also took notice of Craig's abilities, as did fellow student Milford Zornes (b. 1908). Zornes and Craig became friends and painting companions, sharing a small studio in Claremont.

Craig taught at Occidental College beginning in 1935 and also taught at the University of Southern California. During the 1930s he furthered his studies in art at the Chouinard School of Art where he later taught classes, beginning in 1938.

In 1940 Craig won a Guggenheim Fellowship which allowed him to travel and paint in the Southwest. In 1942 he was hired as an artist-correspondent by *Life* magazine. He was sent first to Asia, then to the Italian front.

After the war, Craig's interest in artistic pursuits declined. In 1951 he moved to a 250-acre farm in Escondido, where he returned to a career in botany, concentrating on the cultivation and hybridization of irises.

During his art career, Craig held memberships with the California Art Club, the California Water Color Society, the Laguna Beach Art Association, the Pennsylvania Watercolor Society, and the San Francisco Art Association. He received many prizes and awards, including a first prize, Laguna Beach Art Association, 1936; purchase prize, California Water Color Society, 1939; the Maitland Prize, Second Annual Exhibition of Artists of Los Angeles and Vicinity, 1941; and the Watson F. Blair Purchase Prize, International Water Color Exhibition, Art Institute of Chicago, 1943.

Cuprien, Frank William

Born August 23, 1871 in Brooklyn, New York

Died June 21, 1946 in Laguna Beach, California

Established residence in Southern California, 1912

Frank Cuprien attended the Cooper Union Art School and the Art Students League in New York City. He later studied in Philadelphia with Carl Weber (1850–1921) and also received criticism from noted marine painter William Trost Richards (1833–1905), who would be a major influence.

Cuprien completed his education

with several years of study in Europe; in Munich with Karl Raupp (1837–1918) and in Paris at the Académie Julian. In addition he studied music—voice and piano—at the Royal Conservatories in Munich and Leipzig, from which he graduated in 1905.

Returning to the United States, he first went to Florida and the Gulf of Mexico. He then settled in Waco, Texas, where he taught at Baylor University. Around 1912 he moved to California, living first in Santa Monica and then on Catalina Island. In 1914 he built a studio-home in Laguna Beach, which he called "The Viking." He became one of the leading artists of the community and helped to found the Laguna Beach Art Association in 1918 and served as president from 1921 to 1922. A master of seascapes, Cuprien was often voted the popular prize in the Laguna Beach Art Association exhibitions during the 1920s and 1930s.

Cuprien garnered a number of awards during his career. Among them were a first prize, Fifth Annual Cotton Exhibition, Galveston, Texas, 1913; a silver medal, Panama-California Exposition, 1915; and a bronze medal, California State Fair, 1919.

DeRome, Albert Thomas

Born June 26, 1885 in Cayucos, California

Died July 31, 1959 in Carmel, California

Albert DeRome studied art in San Francisco at the California School of Design in 1904. He supported himself in various jobs as a commercial artist from 1908 to 1914. In 1915 he became a sales manager and agent for a candy manufacturer, and, during his travels in the West, he painted watercolors.

DeRome became the occasional painting companion to artists Gunnar Widforss (1879–1934) and Percy Gray, both excellent watercolorists. He enjoyed traveling around the countryside in one of the many automobiles he owned over the years. Unfortunately, in 1931 he was severely injured in a car accident, left partially paralyzed on the left side and with a speech impediment. He never drove again and, thereafter, relied on family and friends to take him to painting locations.

Some time after his accident, DeRome moved to the Monterey Peninsula. He became friends with Charles "Carlos" Hittell (1861–1938), Will Sparks (1862–1937), and other artists in the area. He became a member of the Carmel Art Association and began to exhibit his work locally. In 1942 he began to participate in the State-Wide Exhibitions in Santa Cruz and received a number of awards at those exhibitions until 1958, the year before his death.

DeRome's works are chiefly small, luminous coastal scenes and landscapes. He painted a great number of sketches, both in oil and in watercolor which he never sold, preferring instead to give them to friends and family members.

Dike, Philip Latimer

Born April 6, 1906 in Redlands, California

Died February 24, 1990 in Claremont, California

Phil Dike received encouragement in art from teacher Louise M. Arnold at Redlands High School. In June 1924 he was awarded a one-year scholarship to the Chouinard School of Art in Los Angeles. He studied there for the next three years under the guidance of noted artists F. Tolles Chamberlin and Clarence Hinkle (1880–1960). In 1928 he went to New York to further his studies at the Art Students League with George Bridgman (1864–1943) and F. Vincent DuMond (1865–1951). He also studied in the studio of noted artist George Luks (1867–1933).

Returning to Los Angeles in 1929, Dike spent a year teaching at Chouinard before embarking on a trip to Europe. Between 1930 and 1931 he studied mural decoration at the American Academy of Art in Fountainbleau, studied lithography in Italy, and traveled and painted throughout France, England, Spain, and Morocco. A still life was accepted at the Paris Spring Salon in 1931.

Having settled again in Los Angeles, Dike began to take frequent painting trips in the Southwest and to Mexico. It was, however, the sea and its shoreline that captured Dike's eye and held it throughout his career. From early childhood he and his family had often spent part of the summer in Newport Beach. His painting *California Holiday* of 1933, one of the earliest interpretations

of Balboa Bay, was published in *Life* magazine in October 1941.

In 1935 Dike obtained a position with Walt Disney Studios as a drawing instructor, color coordinator, and advisor. He assisted in a number of animated feature films including *Fantasia* and *Snow White*. During this period he continued to teach, exhibit, and receive awards for his work.

Dike's professional association with Disney ended in 1945. Thereafter he devoted his time to painting and to teaching. In 1947 he and Rex Brandt cofounded the Brandt-Dike Summer School located at Brandt's home in Corona del Mar. Then, in 1950, at the invitation of Millard Sheets who was director of the graduate art department, Dike joined the faculty of Scripps College in Claremont. He discontinued his staff position at the Brandt-Dike Summer School, thereafter teaching occasionally as a guest artist.

Dike retired from his teaching position at Scripps in 1970, but remained in Claremont, continuing to paint and counsel students who sought his guidance. He was a member of the California Art Club, the California Water Color Society, the American Watercolor Society, the foundation of Western Art, the Laguna Beach Art Association, and the National Academy of Design. His awards, received between 1927 and 1977, were numerous. They included a bronze medal, watercolor, Pacific Southwest Exhibition, Long Beach, 1927; the Evelyn Dalzell Hatfield Gold Medal, California Art Club, 1931; first prize, California Water Color Society, 1931, 1946; first prize, oils, Golden Gate International Exposition, 1940, the Paul B. Remmy A.W.S. Memorial Award, American Watercolor Society, 1962; and the National Academy Award, National Academy of Design, 1977.

Fortune, Euphemia Charlton

Born January 15, 1885 in Sausalito, California

Died May 15, 1969 in Carmel, California

Euphemia Charlton Fortune was born in California but sent to Scotland at

107

the age of twelve to be educated at a convent school in Edinburgh. She then enrolled in the Edinburgh College of Art and then spent a year studying at the St. John's Wood School of Art in London. In 1905 she returned to California and enrolled in the California School of Design. Around 1907 she went to New York to study at the Art Students League. There she met William Merritt Chase (1849–1916) who would be the major influence on her work. At this time she began a career as a portrait painter.

Fortune began a two-year sojourn in England and Scotland in 1910. During this period she visited France for the first time. After her return to Northern California in 1912, she became active in art circles, exhibiting her work at local galleries. In the summer of 1914 she persuaded William Merritt Chase to teach at the Carmel Summer School. The popularity of impressionist ideas was apparent when over 150 students attended his classes.

Fortune established a studio-home in Monterey around 1914 where she taught plein air classes. In 1921 she again went to Europe, spending the next several years dividing her time between London, Cornwall, Paris, Cannes, and St. Tropez. In 1924 her painting of the harbor at St. Ives earned a silver medal at the Paris Salon.

She returned to Monterey in the spring of 1927. The following year she founded the Monterey Guild, a group of ten artists who produced handmade pews, chancels, candelabra, and other such items for Roman Catholic churches. Fortune remained devoted to the guild for the remainder of her career.

Fortune was a member of the California Art Club, the San Francisco Art Association, the Monterey Guild, the Society of Scottish Artists, and the Liturgical Arts Society. Her awards included a silver medal, Panama-Pacific International Exposition, San Francisco, 1915; a silver medal, Panama-California International Exposition, San Diego, 1916; a silver medal, Société des Artistes Français, 1924; the Walter Prize, San Francisco Art Association, 1921, and a first prize, California State Fair, 1930.

Fries, Charles Arthur

Born August 14, 1854 in Hillsboro, Ohio

Died December 15, 1940 in San Diego, California

Established residence in Southern California, 1896

Charles Fries began his art career at the age of fifteen as an apprentice lithographer in the firm of Gibson and Company in Cincinnati. While there, he began studying, in 1872, under Charles T. Webber (1825–1911) at the McMicken School of Design, which later became the Cincinnati Art Academy. Fellow students there included John Twachtman (1853–1902), Frank Duveneck (1848–1919), Henry Farny (1847–1916), and Robert Blum (1857–1903), also an apprentice at Gibson.

Fries worked for a few years as an illustrator and staff photographer for the *Cincinnati Commercial Gazette*. In 1876 he went to London and Paris where he saw the works of the Impressionists. After returning to the United States, he opened a studio in Cincinnati where he made lithographs of his journeys in the Southeast which were published in *Harper's Weekly, Century Magazine,* and *Leslie's Magazine*. His lithograph *Bird's Eye View of Cincinnati*, a scene from a hot air balloon, was used for the poster for the Cincinnati Exposition of 1886.

After his marriage in 1887, he moved his studio to New York City, where he continued to illustrate for books and magazines, among them *McGuffey's Reader* and Eggleston's *History of the United States*. In 1890 he purchased a farm in Vermont. He met Charles Lummis who advised him to go to California. In 1896 he moved his family West, staying first in San Juan Capistrano for several months, then finally settling in San Diego.

After his move to California, Fries devoted all his energy to painting. He was an active member of the art community, teaching and painting in Yosemite, Death Valley, Baja California, and the back country of San Diego. He kept a journal record of his paintings which documented nearly seventeen hundred entries from 1896 to 1940. He became known as the dean of San Diego painters.

Fries was a member of the San Diego

Art Guild, the Contemporary Artists of San Diego, the California Art Club, and the La Jolla Art Association. His awards included a silver medal, Alaska-Yukon-Pacific Exposition, Seattle, 1909; a silver medal, Seattle Fine Arts Society, 1911; and a silver medal, Panama-California Exposition, San Diego, 1915.

Frost, John

Born May 14, 1890 in Philadelphia, Pennsylvania

Died June 5, 1937 in Pasadena, California

Established residence in Southern California, 1918

John Frost was introduced to art by his father, Arthur B. Frost (1851–1928), a well-known American illustrator. When the family moved to Paris, John and his older brother, Arthur B., Jr., took classes at the Académie Julian under Jean-Paul Laurens. Young John worked with the American Impressionist Richard Miller in Paris from 1906–1908 and remained a close friend of the painter, visiting him often at Miller's home in Giverny. In Europe Frost contracted tuberculosis, a disease that would kill his brother, and spent two years in a sanitorium in Switzerland.

The outbreak of World War I saw the Frost family back in New York in 1915, where John worked as an illustrator. In 1919 the family moved to Pasadena, where the warm, dry climate diminished the lingering effects of John's tuberculosis.

Frost admired the works of the Impressionists and maintained that style all his life. He was a close friend and painting companion of Alson S. Clark and Guy Rose, whom he had known in France and who both now lived in Pasadena. Rose had been a lifelong painting and fishing companion of Arthur B. Frost, Sr.

John Frost was a member of the California Art Club, the Painters and Sculptors Club of Los Angeles, and the Pasadena Society of Artists. He won prizes at the Southwest Museum in 1921, 1922, and 1923, and a gold medal at the Painters and Sculptors Club Exhibition in 1924.

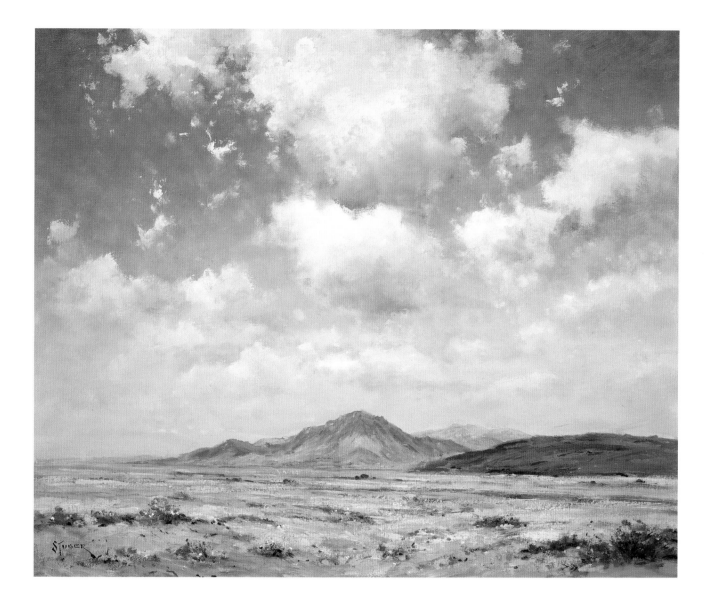

DEDRICK STUBER
Palm Springs Desert, n.d.
Oil on canvas
25 x 30 inches

Palm Spring Desert, *like many of Dedrick Stuber's works, is first and foremost a portrait of light. Portraying light requires an authoritative control of color, for it is the critical placement of color that conveys the effect of light. Only if the artist is accomplished can one truly sense the light of the intense desert sun as it falls on the distant mountains and as it glares off the desert floor.*

Gamble, John Marshall

Born November 25, 1863 in Morristown, New Jersey

Died April 7, 1957 in Santa Barbara, California

First to California, 1883; established residence in Southern California, 1906

John Gamble entered the San Francisco School of Design in 1886, studying there under Emil Carlsen (1853–1931) and Virgil Williams. In 1890 he went to Paris to study at the Académie Julian and the Académie Colarossi. He returned to San Francisco in 1893 to begin his professional career.

He established a national reputation as a painter of wildflowers, although he said that he saw the flowers simply as patches of color: "I liked the way they designed themselves across the field."

When the earthquake and fire struck San Francisco in 1906, Gamble lost his studio and complete inventory of work. Only three paintings, which had been out with a dealer, survived. By the end of the year, Gamble made the decision to move to Los Angeles to be near his close friend, artist Elmer Wachtel. A brief stopover in Santa Barbara persuaded him to relocate to that idyllic community on the coast. He became an active member of the arts community and served on the Santa Barbara Architectural Board of Review, acting as color advisor for new construction.

Gamble was a member of the American Federation of Arts, Foundation of Western Artists, the San Francisco Art Association, and the Santa Barbara Art Association. In 1909 he received a gold medal at the Alaska-Yukon-Pacific Exposition, Seattle.

Gray, Henry Percy

Born October 3, 1869 in San Francisco, California

Died October 10, 1952 in San Francisco, California

Gray's family lineage included a number of writers and painters. That genetic predisposition to artistic talent was evident in his youth. He studied at the San Francisco School of Design beginning in 1886. In 1891 he secured employment as a sketch artist for the *San Francisco Call*. He developed the skills necessary to rapidly record a scene, excellent training for a plein air painter.

In 1895 Gray moved to New York City where he worked as an illustrator for the *New York Journal*, a Hearst publication, and, in 1898, he was made head of the department. While in New York he studied at the Art Students League with William Merritt Chase. When the earthquake and fire devastated San Francisco in 1906, Gray returned home where he went to work for the Hearst paper *Examiner*. The highlight of his career with the *Examiner* was when he was sent to New York to sketch the proceedings of the Harry Thaw trial for the murder of architect Sanford White.

During this period Gray began to focus more time on landscape painting specializing in the medium of watercolor. He traveled throughout Northern California and to Oregon and Arizona. Over the next fifteen years he maintained studios at various locations in and around San Francisco—in the Alameda home of his parents, in Burlingame, in the Portola Valley, and on Montgomery Street. After his marriage in 1923, he moved to the Monterey Peninsula. He joined the Carmel Art Association and became a close friend to artist Arthur Hill Gilbert.

While living in Monterey, Gray would take students on painting trips to Marin and Sonoma counties. He would sketch on location, later creating finished works in his studio. He worked in oil, yet is best known for his paintings in watercolor. These quiet, lyric paintings are distinctly characteristic, following the English tradition of carefully applied, transparent washes. He noted that he was not so much painting the scene, as he was painting the atmosphere.

Gray was a member of the Bohemian Club, the Carmel Art Association, The Family (San Francisco), and the Society for Sanity in Art. His awards included a bronze medal for watercolor, Panama-Pacific International Exposition, San Francisco, 1915; and first prize for watercolor, Arizona Art Exhibition, Phoenix, 1915.

Griffith, William Alexander

Born August 19, 1866 in Lawrence, Kansas

Died March 25, 1940 in Laguna Beach, California

First to California, 1918; established residence in Southern California, 1920

William A. Griffith studied at the State Normal School in Emporia, Kansas and later enrolled in Washington University in St. Louis where he studied art. In 1890, with his friends Benjamin Brown and Edmund H. Wuerpel (1866–1958), he went to Europe. In Paris he enrolled in the Académie Julian, studying there for two years.

After returning to the United States, Griffith obtained a teaching position at Washburn College, then at St. Louis School of Art. In 1899 he joined the faculty of the University of Kansas at Lawrence as a professor, and later, head of the drawing and painting department, a position he held for twenty-one years. While at the university he organized exhibitions from the Art Institute of Chicago, the Carnegie Institute in Pittsburgh, and the Freer Gallery in New York City. He helped form the honorary art fraternity Delta Phil Delta in 1909. It was also through his efforts that the university received the gift of the William B. Thayer Collection of Kansas City, which was the beginning of the Spencer Art Galleries.

Griffith's friend Benjamin Brown had moved to California in 1896 and encouraged him to move there as well. He spent time in California during a sabbatical leave from 1918 to 1919. Having suffered from chronic bronchial problems for a number of years, Griffith found the warm, semiarid climate appealing. In 1920 he moved permanently to the area, settling in Laguna Beach where he immediately became active with the Laguna Beach Art Association. Serving as president from 1920 to 1921 and 1925 to 1927, Griffith helped organize fund-raising efforts for the building of the permanent gallery on Cliff Drive.

Noted for works in both oil and pastel, Griffith received a number of awards, including the Wyman Crow Gold Medal, St. Louis, 1899; a first prize, Los Angeles County Fair, 1928; a first prize, pastels, Second Annual All-California Exhibition, Santa Cruz Art League, 1929; and a second prize, California Art Club, 1934.

Hansen, Armin Carl

Born October 23, 1886 in San Francisco, California

Died April 23, 1957 in Monterey, California

Armin Hansen received tutoring in art as a child from his father, artist Hermann Wendleborg Hansen (1854–1924), who was known for his paintings of the American western frontier. The younger Hansen then studied at the California School of Design under Arthur Mathews from 1903 to 1906. In 1906 he went to Germany where he studied for two years under the impressionist Carlos Grethe at the Royal Academy in Stuttgart. During his time in Germany, Hansen visited the art centers in Munich and Paris and traveled to Holland and Belgium. Around 1908 he went to Nieuwpoort on the coast of Belgium, where he painted scenes of the life of North Sea fishermen. For the next few years he painted there and at the seaport town of Oostend while working occasionally as a deckhand. His love for the sea would be reflected in his work for his entire career.

Hansen returned to the United States in 1912 and taught for several months at the University of California at Berkeley. The next year he moved to Monterey where he became an active member of the art community and mentor for young artists. He became known for his marine paintings and etchings which recorded the activities of that bustling fishing community. In 1918 his privately held classes were incorporated into the California School of Fine Arts as the Monterey Summer School. Hansen was made director and instructor for landscape classes. His influence on aspiring artists was profound, and former students refer to the period of the 1920s in Monterey as the "Golden Era" for both artistic and social activities.

Hansen exhibited widely, both in California, in the Eastern United States, and in Europe. He helped to found the Carmel Art Association and held memberships in the California Society of Etchers, the Salmagundi Club, the San Francisco Art Association, and the Société Royale des Beaux-Arts, Brussels. Elected to the National Academy of Design in 1925, he gained full Academician status in 1948. His numerous awards included first prize, International Exposition, Brussels, 1910; a silver medal, Panama-Pacific International Exposition, San Francisco, 1915; a purchase prize, San Francisco Art Association, 1916; gold medals in drawing and in painting, San Francisco Art Association, 1919; First Hallgarten Prize, National Academy of Design, 1920; the Ranger Fund Purchase Prize, National Academy of Design, 1925; and a gold medal, Painters of the West, 1925.

Harris, Sam Hyde

Born February 2, 1889 in Brentford, England

Died May 30, 1977 in Alhambra, California

To the United States, 1904; established residence in Southern California, 1904

Sam Hyde Harris immigrated to the United States with his family in 1904, settling in Los Angeles. He pursued a career as a commercial artist in the advertising field while studying in the evenings at the Art Students League and at the Cannon Art School with F. Tolles Chamberlin, Stanton MacDonald-Wright (1890–1973), and Hanson Puthuff. In 1913 he spent six months in Europe where he was inspired by the light and atmospheric effects in the works of John Constable and J. M. W. Turner.

Returning to Los Angeles, Harris continued to pursue a successful commercial career, designing advertisements and posters for the Southern Pacific, Union Pacific, and Santa Fe railroads. He also created the windmill logo for Van De Kamp's Bakeries, which is still used today.

During the 1920s Harris studied privately with Hanson Puthuff, taking painting trips with him to the deserts of California and Arizona. He also painted with Jean Mannheim and Edgar Payne. He liked to paint in the rural environs of Pasadena and San Gabriel, as well as in the city of Los Angeles. During the 1930s he painted harbor scenes in San Pedro, Sunset Beach, and Newport Beach. During the 1940s and 1950s he often painted in the desert with James Swinnerton (1875–1974).

Harris was a member of the California Art Club, the Painters and Sculptors Club, and the Laguna Beach Art Association. He received a silver medal from the Painters and Sculptors Club in 1944 and a special award from the California Art Club in 1941.

Hills, Anna Althea

Born January 28, 1882 in Ravenna, Ohio

Died June 13, 1930 in Laguna Beach, California

Established residence in Southern California, 1912

Anna Hills received her education at Olivet College in Michigan, the Art Institute of Chicago, and the Cooper Union Art School in New York City. She worked with Arthur Wesley Dow (1857–1922) for two years. She then went to Europe where she studied at the Académie Julian and traveled and painted in Holland and England, where she studied with John Noble Barlow (1861–1917).

She returned to the United States and moved to Los Angeles around 1912. A year later she relocated to Laguna Beach where she became a founding member of the Laguna Beach Art Association in 1918. She became an indefatigable leader of that group, serving as president from 1922 to 1925 and from 1927 to 1930, the period during which the group raised the funds necessary to build their permanent gallery on Cliff Drive. A highly respected teacher, Hills promoted the visual arts through lectures and the organization of special exhibits which circulated among Orange County public schools.

Originally a figure painter, Hills turned to the landscape after her move to California. In addition to the Laguna Beach Art Association, Hills held memberships in the California Art Club and the Washington Water Color Club. Among her awards were a bronze medal, Panama-California Exposition, San Diego, 1915; a bronze medal, California State Fair, 1919; and the landscape prize, Laguna Beach Art Association, 1922, 1923.

Judson, William Lees

Born April 1, 1842 in Manchester, England

Died October 26, 1928 in Los Angeles, California

To the United States, 1852; established residence in Southern California, 1893

William Lees Judson came to the United States with his family in 1852 living in Brooklyn, New York. His early arts education was from his father who was an artist. Judson served in the military during the Civil War and afterwards studied briefly with John B. Irving in New York. He went to Paris and studied at the Académie Julian from 1878 to 1881.

Around 1890 Judson moved to Chicago where he was active as a portrait painter. Ill health caused him to seek a milder climate, and, in 1893, he came to Los Angeles. He taught at the Los Angeles School of Art and design and began to paint the landscape.

In 1896 he joined the faculty of the University of Southern California as Professor of Drawing and Painting. In 1901 he founded and was made the first dean of the USC College of Fine Arts, located on the Arroyo Seco in Garvanza. A fire destroyed the school in December 1910, and it was reported that Judson lost many paintings. The school was immediately rebuilt, and Judson continued in his post until his death.

Judson was a versatile artist. An adept impressionist painter, he was also originator of the Craftsman movement in the Arroyo Seco area of Pasadena. The tradition endured, and the Judson Studios still produce excellent stained-glass windows in the original Judson home in Pasadena.

Judson was a member of the California Art Club and the Laguna Beach Art Association. His awards include a bronze medal at a London exhibition in 1886, a bronze medal at the Panama-California Exposition in San Diego in 1915, and the Popular Prize at the Southwest Museum in 1921.

Kleitsch, Joseph

Born June 6, 1882 in Nemet Szent Mihaly, Hungary (present-day Romania)

Died November 16, 1931 in Santa Ana, California

To the United States, 1901; established residence in Southern California, 1920

In his teens, Joseph Kleitsch was apprenticed to a sign painter, but left after about eighteen months to open his own studio as a portrait painter. Around 1901 he immigrated to Germany and then to the United States, settling in Cincinnati, Ohio. Around 1905 he moved to Denver where he did portraits of prominent businessmen. About 1907 he was in Hutchinson, Kansas, but, after only a short time, he relocated to Mexico City, residing there between 1907 and 1909. Sometime in 1909 he moved to Chicago.

In 1912 Kleitsch achieved recognition for commissioned portraits he had done of Mexican President Francisco Madero and his wife. Well established as a portrait painter, he joined the Palette and Chisel Club and began participating in local exhibitions with the club and at the Art Institute of Chicago around 1914. He began to paint interior scenes with figures, often placed in front of a window. He received high praise for these works and was compared favorably to the Spanish artist Joaquin Sorolla (1863–1923) as well as to Rembrandt.

In 1920 Kleitsch moved to Southern California, establishing residency in Laguna Beach. He was already acquainted with artists who had preceded him such as Edgar Payne. He again established himself as a portrait painter—his main source of income—but also began to include landscape and still lifes in his oeuvre. He was as a bold colorist, employing a bravura brushstroke. He especially enjoyed painting in and around Laguna Beach, whose charms he knew would soon succumb to real estate development.

In 1925 Kleitsch traveled to Europe, visiting France and Spain where he painted portraits and landscapes. He returned to California in November 1927 where he continued to paint until his untimely death at the age of forty-nine.

Kleitsch held memberships with the Chicago Society of Artists, the Laguna Beach Art Association, the Palette and Chisel Club of Chicago, and the Painters and Sculptors Club, which he co-founded in 1923 with Grayson Sayre. The numerous awards which he had garnered during his career included a gold medal, Palette and Chisel Club; a silver medal, Painters and Sculptors Club; a first prize, California State Fair; and a first prize and figure prize, Laguna Beach Art Association.

Lauritz, Paul

Born April 18, 1889 in Larvik, Norway

Died October 31, 1975 in Glendale, California

To Canada, 1905; established residence in Southern California, 1919

Paul Lauritz studied as a youth at the Larvik Art School. At the age of sixteen he immigrated to eastern Canada, then worked his way West, settling in Portland, Oregon, where he found commercial art work. Lured by tales of Alaskan gold, he traveled to the remote region where he painted dramatic mountain scenes. While there, he met and exhibited with artist Sydney Laurence (1865–1940).

In the latter part of 1919 Lauritz moved to Los Angeles where he opened a studio. He began teaching at the Chouinard School of Art in 1928 and later also taught at Otis Art Institute. He was a member of the Los Angeles Municipal Art Commission for six years where he helped to organize the first municipal art exhibitions.

Lauritz specialized in landscape work and painted along the coast from Laguna Beach to Monterey, in the High Sierras, and in the deserts of California, Nevada, and Mexico. He returned to his native Norway in 1925 where, in 1928, he received a special commission from the king.

Lauritz was an active member of the Laguna Beach Art Association, the Painters and Sculptors Club, and the California Art Club where he served two years as president. He also held memberships in the Salmagundi Club and the Royal Society of Art in England. He received a number of awards including a purchase prize, San Diego Musuem of Art, 1928; first prize, California State Exposition, 1922, 1923, 1924; and first prize, California Art Club, 1947, 1949, 1950, 1952, and 1953.

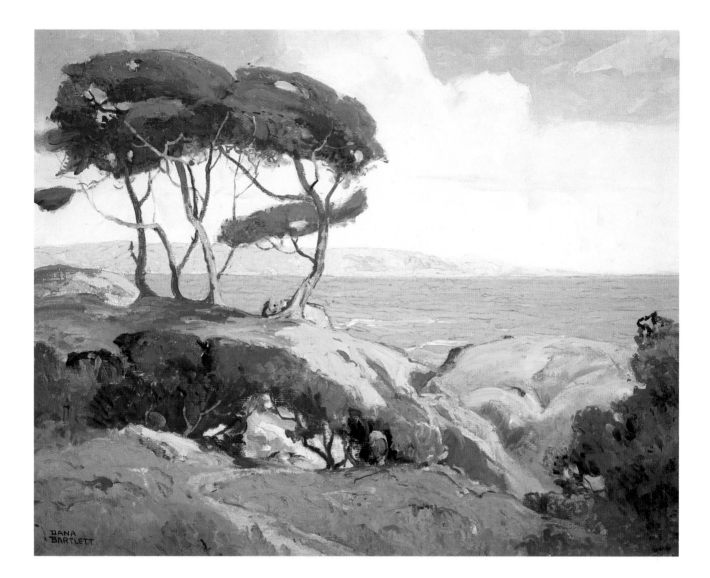

DANA BARTLETT
By Morro Bay, n.d.
Oil on canvas
24¹/₂ x 29¹/₂ inches

Dana Bartlett was known for his decorative, impressionist landscapes. The few figures in the composition are uncharacteristic of his work. They are sheltered by the trees whose undulating forms convey the sense of wind and atmosphere found along the coast of central California.

Mannheim, Jean

Born November 18, 1862 in Kreuznach, Germany

Died September 6, 1945 in Pasadena, California

To the United States, 1881; established residence in Southern California, 1908

Jean Mannheim studied in Paris at the Académie Delecluse, the Académie Colarossi, and the Académie Julian. In 1881 he went to the United States, residing with his sister in Chicago, and while there earned money as a portrait painter. Each summer he returned to Europe where he continued his art studies.

Around 1903 Mannheim began teaching in London at the Brangwyn School of Art, operated by Frank Brangwyn (1867–1956). He returned to the United States two years later, settling briefly in Denver where he taught at the Denver Art School. He moved to Los Angeles in 1908, opened a studio in the Blanchard Building, and began teaching in his own school. He built a studio-home on the Arroyo Seco in Pasadena. After the death of his wife in 1910, he worked primarily out of his home in order to care for his young daughters.

An active participant in the Los Angeles art community, Mannheim was a founding member of the California Art Club and the Laguna Beach Art Association. He was also a member of the Pasadena Art Club and the Long Beach Art Association. Known for his figure works, as well as his landscapes, Mannheim received a number of awards. Among them were a gold medal, Alaska-Yukon-Pacific Exposition, Seattle, 1909; gold and silver medals, Panama-California Exposition, San Diego, 1915; and a first prize, London School of Art.

Mitchell, Alfred R.

Born June 18, 1888 in York, Pennsylvania

Died November 9, 1972 in San Diego, California

Established residence in Southern California, 1908

Alfred Mitchell came to California in 1908, settling in San Diego where, in 1913, he began to study at the San Diego Academy of Art under Maurice Braun. His talents were acknowledged just two years later when he received a silver medal at the Panama-California Exposition in San Diego. Encouraged by Braun, Mitchell decided to return to his native Pennsylvania in 1916 and enroll in the Pennsylvania Academy of the Fine Arts where he was influenced by Daniel Garber (1880–1958) and Edward Redfield (1869–1965). In 1920 he was awarded the Cresson European Traveling Scholarship, which allowed him to spend the summer of 1921 in England, France, Italy, and Spain.

Upon completion of his studies, Mitchell returned to San Diego where he became an active member of the art community. He played a leading role in the formative years of the Fine Arts Gallery of San Diego and, in 1929, was a founding member of the Associated Artists of San Diego. He was also a member of the La Jolla Art Association.

Mitchell's early works are impressionistic, reflecting his tutelage under Braun, Garber, and Redfield. His later works, however, are more strongly realistic which reflected his admiration for the work of Thomas Eakins (1844–1916).

Mitchell received numerous awards in addition to those previously mentioned. Among them were the Edward Bok Philadelphia Prize, the Pennsylvania Academy of the Fine Arts, 1920; the Leisser Farnham Prize, San Diego, 1927; the highest award, Laguna Beach Art Association, 1940; and both a first prize and purchase prize, San Diego Art Institute Annual, 1960.

Nelson, Ernest Bruce

Born June 13, 1888 in Santa Clara County, California

Died 1952 in New York City

Bruce Nelson studied civil engineering at Stanford University beginning in 1905. There he met Robert B. Harshe (1879–1938), who was head of the art department, and after three years, he transferred his interests to architecture.

After leaving Stanford he worked for an architectural firm in San Francisco. He then went to New York and enrolled in the Art Students League. He also attended the Woodstock Summer School under Birge Harrison (1854–1929). He returned to San Francisco in 1912 and began exhibiting, immediately receiving positive criticism.

In the summer of 1913 Nelson opened a studio in Pacific Grove where he offered private and group classes. He continued to exhibit his paintings in San Francisco and in Los Angeles. Nelson served in the Army Camouflage Corps during World War I and, after his discharge in 1918, he went to Cooperstown, New York, where he painted murals at the home of James Fennimore Cooper. It is believed that he then moved to New York City where he died in 1952.

In 1914 Alma May Cook of the *Los Angeles Tribune* predicted that Nelson would some day take a high place in the annals of American art. (17 May 1914) Yet, mysteriously, the last exhibition record for Nelson appeared in 1924. During his short career he was accorded a one-man show at the opening of the Oakland Art Gallery in 1916 and received a silver medal at the Panama-Pacific International Exposition in 1915 for *The Summer Sea*.

Payne, Edgar Alwin

Born March 1, 1883 in Washburn, Missouri

Died April 8, 1947 in Hollywood, California

First to California, 1909; established residence in Southern California, 1917

Edgar Payne was essentially a self-taught artist who left home around 1902 at the age of nineteen. He traveled for a number of years throughout the South, the Midwest, and in Mexico, taking various jobs as a house painter, sign painter, scenic painter, and portrait and mural artist. He settled in Chicago in 1907 where he enrolled briefly in a portraiture class at the Art Institute of Chicago, leaving after only two weeks. At this time he began landscape painting in the form of murals and small easel works. He exhibited with the Palette and Chisel Club from which he sold some of his paintings.

Payne visited California in 1909 and spent some time painting in Laguna Beach. He also visited San Francisco where he met his future wife, artist Elsie Palmer (1884–1971). He visited California a second time in 1911 and mar-

ried Elsie in November 1912. They lived in Chicago until 1917, during which time they became well established in the art circles, Payne exhibiting at the Art Institute of Chicago as well as the Palette and Chisel Club. He continued with his mural work and made annual trips to California.

In the summer of 1917 they moved to Glendale, California; then, in November they moved to Laguna Beach. Payne became active in the art colony there and was a founding member and first president of the Laguna Beach Art Association in 1918.

Payne was an inveterate traveler who painted throughout California, Arizona, and New Mexico, as well as in Canada. No locale was too remote, and he spent a great deal of time in the High Sierras, living for weeks at his elaborate campsites. In the summer of 1922 the Paynes went to Europe, painting over a two-year period in France, Switzerland, and Italy. His favorite painting locations were the Alps and in the fishing ports. His painting of Mont Blanc, entitled *The Great White Peak*, received an honorable mention at the Paris Salon in the spring of 1923.

After their return to the United States in the fall of 1924, the Paynes spent some time again in Chicago, then returned to Laguna Beach. Over the next several years they spent time in California, Connecticut, and New York and made painting trips to the California Sierras, Utah, and New Mexico. In 1928 another trip was made to Europe where Payne painted in the harbors of Italy and France.

Payne was a member of the California Art Club, the Painters and Sculptors of Southern California, the Chicago Art Club, the Palette and Chisel Club of Chicago, and the Salmagundi Club in New York City. His works were exhibited nationally in Chicago and New York. His many awards included the Martin B. Cahn Prize, Art Institute of Chicago, 1921; a gold medal, California Art Club, 1925; and the Ranger Fund Purchase Award, National Academy of Design, 1929. He wrote *Composition of Outdoor Painting*, published in 1941, which is now in its fourth edition.

Puthuff, Hanson Duvall

Born August 21, 1875 in Waverly, Missouri

Died May 12, 1972 in Corona del Mar, California

Established residence in Southern California, 1903

Hanson Puthuff attended the University of Denver Art School, graduating in 1893 at the age of eighteen. He later studied at the Chicago Academy of Fine Arts. For a brief period he worked as a mural painter before returning to Denver in 1894. There he found employment designing posters for an advertising firm.

Puthuff moved to Los Angeles in 1903 where he continued his profession of painting billboard posters. He also began to paint easel works which he first exhibited in 1905. *Los Angeles Times* art critic Antony Anderson gave him a favorable review, and the two men became friends. Together they founded the Art Students League in Los Angeles.

Puthuff went to Chicago in 1906 for one year, working as a scene painter and participating in the local art scene. He returned to Los Angeles the following year and began to devote more time to his painting. He was a founding member of the California Art Club and was also a member of the Laguna Beach Art Association, the Pasadena Society of Artists, and the Painters and Sculptors Club.

In the 1920s Puthuff painted dioramas for the Los Angeles Museum of Science, History, and Art. He gave up his commercial career in 1926 in order to concentrate all his time on his easel painting. Many of his works depict the environs of his home in La Crescenta. He also painted in the Sierras and in the canyons of Arizona.

Puthuff received a number of awards including two silver medals, Panama-California Exposition, San Diego, 1915; a gold medal, California State Fair, Sacramento, 1918; a first prize, Laguna Beach Art Association, 1920 and 1921; a gold medal, Painters of the West, 1927; a silver medal, Pacific Southwest Exposition, Long Beach, 1928; and a purchase prize, Chicago Galleries Association, 1931.

Redmond, Granville Richard Seymour

Born March 9, 1871 in Philadelphia, Pennsylvania

Died May 24, 1935 in Los Angeles, California

Granville Redmond contracted scarlet fever at the age of two and a half, which resulted in permanent deafness. His family moved to California in 1874, and, in 1879, Redmond enrolled in the Institution for the Deaf, Dumb, and Blind at Berkeley (now the California School for the Deaf, Fremont). His artistic talents were recognized and encouraged by the deaf photographer and teacher Theophilus Hope d'Estrella (1851–1929), who taught him drawing and pantomime. He also received sculpture lessons from the deaf sculptor Douglas Tilden (1860–1935).

After graduation in 1890 Redmond enrolled in the California School of Design. In 1893, with a stipend from the Institution for the Deaf, he went to Paris where he enrolled in the Académie Julian. After five years in France, he returned to California and opened a studio in Los Angeles. For the next several years he painted in and around the area, including Laguna Beach, Long Beach, Catalina Island, and San Pedro. He visited and painted in Northern California in 1902 and 1905.

In 1908 he relocated to Parkfield on the Monterey Peninsula where he resumed his friendships with his former classmates from the California School of Design, Gottardo Piazzoni (1872–1945) and Xavier Martinez (1869–1943). He moved to San Mateo in 1910 and had a studio in Menlo Park.

In 1917 he traveled to Los Angeles with Gottardo Piazzoni and, with his natural skills as a pantomimist, decided to try his hand in motion pictures. He met Charlie Chaplin who cast him in a small role in *A Dog's Life*. Chaplin became a close friend, setting up a painting studio for Redmond on his movie lot. In turn he taught Chaplin sign language, and, between 1918 and 1929, he had minor roles in seven movies. During this period he painted throughout Southern California.

Redmond was, without question, one of California's leading landscape painters. Although he preferred his works done in a more tonalist style, his patrons favored his paintings of the rolling hills covered with golden poppies. He was a member of the Bohemian Club, the San Francisco Art As-

sociation, the California Art Club, and the Laguna Beach Art Association. His awards included the W. E. Brown Gold Medal, California School of Design, 1891; award, Louisiana Purchase Exposition, St. Louis, 1904; and a silver medal, Alaska-Yukon-Pacific Exposition, Seattle, 1909.

Reiffel, Charles
Born April 9, 1862 in Indianapolis, Indiana

Died March 14, 1942 in San Diego, California

Established residence in Southern California, 1927

While in his teens, Charles Reiffel began to work in a clothing store in Cincinnati, a position he held for ten years. While there, he would doodle on pieces of paper, and this interest in artistic line led him to become a journeyman lithographer. That career took him to New York and then to England where he designed posters. He stayed there six years and during that period began to paint in his spare time. He took a nine-month leave to travel throughout Europe and North Africa and studied briefly at the Munich Academy under Carl Marr. The influence of the Munich artists, who emphasized color, texture, and line over subject matter, was profound.

Reiffel returned to the United States in 1904 and resided in Buffalo, New York where he continued to work as a lithographer. He began to exhibit his paintings at the Albright-Knox Art Gallery in Buffalo and received favorable reviews. Soon other East Coast galleries and museums took note of his work.

In 1912 Reiffel moved to the artists' colony in Silvermine, Connecticut. He helped to organize the Silvermine Artists' Guild and, after several years of commuting to his lithography job in New York, he resigned to become a full-time painter. In 1925 he decided to explore the Southwest. He headed for Santa Fe, but a storm diverted him to San Diego. Charmed by the location, he decided to remain. He became an active member of the art community there, but unfortunately found that the art market was more conservative than in the East, and his paintings did not sell.

Reiffel held memberships in many arts organizations including the California Art Club, the Chicago Galleries Association, the Cincinnati Art Club, the Laguna Beach Art Association, the Salmagundi Club, the San Diego Art Guild and the Arts Club of Washington, D.C. His many awards included a silver medal, Art Institute of Chicago, 1917; a gold medal, California Art Club, 1928; a gold medal, Painters of the West, 1930; first prize, John Herron Art Institute, 1929; and the John C. Shaffer Grand Prize, Hoosier Salon, 1938.

Rider, Arthur Grover
Born March 21, 1886 in Chicago, Illinois

Died January 25, 1976 in Los Angeles, California

First to California, late 1920s; established residence in Southern California, 1931

Arthur Rider attended the Chicago Academy of Fine Arts. He then went to Europe where he studied at the Académie Colarossi and the Académie de la Grande Chaumière in Paris. He spent several summers in Valencia, Spain, studying at the Werntz Academy of Fine Arts. It was there that he befriended noted artist Joaquin Sorolla (1863–1923), who would be a great influence on his work.

Rider returned to Chicago where he became an active participant in the art community. After visiting California in the late 1920s, he settled permanently there in 1931. He worked for Twentieth Century Fox and MGM studios, retiring at the age of eighty-four.

Rider painted throughout California and Mexico, seeking locales which would remind him of the color and light he had seen in Spain. His paintings are rich in color with intense, brilliant light. Many of his Spanish pictures depict the activities of fisherman on the beach in Valencia and their boats with the single, white billowing sail.

Rider held memberships in the Palette and Chisel Club, the Chicago Galleries Association, the California Art Club, the Painters and Sculptors Club, and the Laguna Beach Art Association. He was awarded a purchase prize, Art Institute of Chicago, 1923; second prize, California State Fair, 1936; first prize, California Art Club, 1940; and first prize, Painters and Sculptors Club, 1954.

Ritschel, William Frederick
Born July 11, 1864 in Nuremberg, Germany

Died March 11, 1949 in Carmel, California

Established residence in Northern California, 1911

As a youth William Ritschel spent several years as a sailor. He then entered the Royal Academy of Design in Munich where he studied under Friedrich August von Kaulbach and Karl Raupp. The two experiences combined to make marine painting the primary focus of his work. After completing his studies he traveled and painted extensively throughout Europe for a number of years, showing his work in exhibitions in Berlin, Munich, and Paris.

In 1895 Ritschel immigrated to the United States, settling in New York. He began participating in exhibitions there and received praise for his work. Some time after 1909 he decided to move to California. He purchased land high on a bluff overlooking the Pacific Ocean in Carmel Highlands, and there, in 1918, he had constructed a castle-like, stone home based on a 15th century Basque design. Dubbed by the artist "Castle a Mare," the home afforded impressive views of the ocean below.

It was the love of the ocean that lured Ritschel to the South Seas where he painted in 1921 and 1922. He also went to Capri and the Orient in 1924, and made a trip around the world in 1926. He filled his studio-home with many objects and sculptures collected on his trips. His paintings of the sea in its many moods and of man's relationship to it brought him high praise in Europe as well as in the United States where he was called "Dean of American Marine Painters."

Ritschel was elected to the National Academy of Design in 1910 and made a full academician in 1914. He was also a member of the American Watercolor Society, the Salmagundi Club, the San Francisco Art Association, the Academy of Western Painters, and the

JEAN MANNHEIM
Aliso Canyon and Bridge at Coast Highway, n.d.
Oil on canvas
24 x 36 inches

Aliso Creek winds its way out of the mountains and meets the sea at Laguna Beach. In 1930 the old wooden bridge on Pacific Coast Highway, depicted in this painting, was replaced by a concrete structure still in use today.

Carmel Art Association. His many awards included the Carnegie Prize, National Academy of Design, 1913; gold medal, Panama-Pacific International Exposition, San Francisco, 1915; Ranger Fund Purchase Prize, National Academy of Design, 1921, 1926; the Harris Prize, Art Institute of Chicago, 1923; and an honorable mention, Paris Salon, 1926.

Rose, Guy

Born March 3, 1867 in San Gabriel, California

Died November 17, 1925 in Pasadena, California

Guy Rose attended the California School of Design in 1886 and 1887, studying under Virgil Williams and Emil Carlsen (1853–1932). In 1888 he went to Paris and enrolled in the Académie Julian. He was an apt student who soon found his paintings accepted for the annual Paris Salon exhibitions.

In 1894 Rose experienced a bout of lead poisoning which forced him to abandon oil painting. He returned to the United States in the winter of 1895 and began a career as an illustrator. He also taught drawing and portraiture at Pratt Institute in Brooklyn. He began to paint again around 1897.

In 1899 he returned to Paris, where he continued to do illustration work for *Harper's Bazaar* and other American magazines. In 1904 he settled in Giverny, becoming a member of the American art colony there. He associated with artists Richard Miller (1875–1943), Lawton Parker (1868–1939), and Frederick Frieseke (1874–1939). He was strongly influenced by Monet, although it is not established whether the two ever met. Frieseke, Miller, Parker, and Rose exhibited in New York in 1910 as "The Giverny Group."

Rose returned permanently to the United States in 1912, settling for a time in New York. He moved to Pasadena at the end of 1914 and became active in the local art circles, serving for several years on the board of trustees of the Los Angeles Museum of History, Science and Art. He became the director of the Stickney Memorial School of Fine Arts in Pasadena and persuaded Richard Miller to teach at the school in 1916.

Rose painted primarily in the southern part of the state until about 1918, at which time he went to Carmel and Monterey. He developed a serial style of painting like that of Monet, in which the same scene would be depicted in different seasons and at different times of day.

Rose was a member of the California Art Club and the Laguna Beach Art Association. Three one-man exhibitions were held for him at the Los Angeles Museum, in 1916, 1918, and 1919. He was represented in Los Angeles by Stendahl Galleries and in New York by William Macbeth. Among his numerous awards were a bronze medal, Pan-American Exposition, Buffalo, 1901; a silver medal, Panama-Pacific International Exposition, San Francisco, 1915; and the William Preston Harrison Prize, California Art Club, 1921. He was disabled by a stroke in 1921, four years before his death.

Sayre, Fred Grayson

Born January 9, 1879 in Medoc, Missouri

Died January 1, 1939 in Glendale, California

Established residence in Southern California, 1917

Grayson Sayre was essentially self-taught. As a youth he enrolled in a correspondence course in pen-and-ink drawing. He then studied briefly with J. Laurie Wallace (1864–?) in Omaha, Nebraska and also with John Vanderpoel (1857–1911) at the Art Institute of Chicago.

Sayre began his career as an illustrator in St. Louis, where he also taught illustration at the Stanberry Normal School and at Webb City College. He briefly resided in Houston where he worked as an engraver, then moved to Chicago where he worked as an illustrator. He developed a reputation as an excellent black-and-white artist.

After a bout with diphtheria in 1916, he was advised by his doctors to seek a milder climate. He headed west and, from 1919 to 1922, traveled throughout the desert Southwest in Arizona and Southern California. He would periodically stay with his parents who were living in Glendale and with a cousin who lived in Thermal. In 1924 Sayre built a studio-home in Glendale and another in

the Coachella Valley near Palm Springs where he spent his winters. His favorite subject was the desert where he sensed "a message in the vast lonely spaces."

Despite his constant travels, Sayre was an active member of the Los Angeles art community. In 1923, with Joseph Kleitsch, he founded the Painters and Sculptors Club, which was modeled after the Salmagundi Club in New York City and the Palette and Chisel Club in Chicago. He was also a member of the California Water Color Society and the Painters and Sculptors of Southern California. He received the Artland Club Purchase Prize, Pacific Coast Artists Exhibition, 1927; a gold medal, Painters and Sculptors Club, 1928; and a purchase prize, Gardena High School, 1931.

Schuster, Donna Norine

Born January 6, 1883 in Milwaukee, Wisconsin

Died December 27, 1953 in Los Angeles, California

Established residence in Southern California, 1913

Donna Schuster attended the Art Institute of Chicago where she graduated with honors. She then studied at the Boston Museum of Fine Arts School with Edmund C. Tarbell (1862–1938) and Frank W. Benson (1862–1951). She went on a painting tour of Belgium in 1912 with William Merritt Chase (1849–1916) and won the William Merritt Chase Prize.

Schuster moved to Los angeles in 1913 and the following summer studied once again with Chase at the Carmel Summer School. In the fall of 1914 she made a series of watercolor sketches in San Francisco depicting the construction of the buildings for the Panama-Pacific International Exposition. These were later exhibited at the Los Angeles Museum of History, Science, and Art.

In 1923 she built a studio-home in the hills of Griffith Park in Los Angeles and she joined the faculty of Otis Art Institute. She spent her summers at a second studio-home in Laguna Beach. In 1928 she began to study with Stanton MacDonald-Wright

GRAYSON SAYRE
Cottonwood Rancho, n.d.
Oil on canvas
20 x 24 inches

(1890–1973), and thereafter her work reflected the influence of Cubism and, later, Abstract Expressionism.

Schuster was active in many arts organizations, holding memberships in the California Art Club, the Laguna Beach Art Association, West Coast Arts, and the California Water Color Society, of which she was a founding member. She was also a member of the "Group of Eight," who considered themselves modernist in their use of rich color, expressive painting techniques, and an emphasis on the human figure. She received numerous awards including a silver medal, watercolors, Panama-Pacific International Exposition, San Francisco, 1915; a gold medal, California State Fair, 1919; and a gold medal, Painters of the West, 1924 and 1929.

Sheets, Millard Owen

Born June 24, 1907 in Pomona, California

Died March 31, 1989 in Gualala, California

Millard Sheets grew up on his grandfather's ranch in Pomona. There he developed a love of the land and of horses, both of which would be manifested in his art. His artistic expressions began in his youth, and in 1925 he enrolled in the Chouinard School of Art on a scholarship, studying under Clarence Hinkle (1880–1960) and F. Tolles Chamberlin. There he became a close friend to fellow student Phil Dike. Sheets developed a particular affinity for the medium of watercolor; within eighteen months of enrolling and while still a student, Mrs. Chouinard hired him to organize and teach a watercolor class.

In the spring of 1929, not yet finished with his studies, he was given a one-man show at the Newhouse Galleries in Los Angeles. He also received a major cash award in the San Antonio Competitive Exhibition, which enabled him to travel to South America, Central America, and Europe for nearly a year during which time he painted, sketched, studied lithography in Paris, and had a painting accepted at the Paris Salon.

He returned to Los Angeles in 1930 and soon became one of the most dynamic members of the art community. He held a variety of teaching and administrative positions from 1931 to 1956: from 1931 to 1956 he was the Director of the Fine Arts Exhibition at the Los Angeles County Fair; from 1932 to 1955 he was a teacher at Scripps College and Director of Arts beginning in 1936. He served as one of the four directors of the Southern California Public Works of Art Program from 1933 to 1935.

An active exhibitor, Sheets encouraged fellow members of the California Water Color Society to enter art exhibitions in the Midwest and the East, among them the International Water Color exhibitions at the Art Institute of Chicago and the Philadelphia Water Color Club exhibitions held at the Pennsylvania Academy of the Fine Arts.

It was at Claremont that Sheets made his greatest impact as an educator. Joining the faculty in 1932 as an assistant professor of art, he was the driving force to create one of the country's finest college art departments. As director of the art department from 1936 to 1955, Sheets brought many important artists to teach at the school, including Henry Lee McFee (1886–1953), Albert Stewart (1900–1965), Phil Paradise (b. 1905), and Phil Dike.

Sheets was also interested in architecture, and between 1939 to 1941 he designed seventeen Air Training Schools for the United States Army Air Corps. In 1942 he was made an artist-correspondent for *Life* magazine, assigned to the China-Burma-India theater.

After the war Sheets returned to his teaching and to his position at the Los Angeles County Fair, mounting major international exhibitions until his resignation in 1956. Between 1953 and 1959 he was the director of the Otis Art Institute in Los Angeles, which awarded him an honorary M.F.A. in 1963.

In 1954 he was contracted to design the Ahmanson Bank and Trust Company in Los Angeles, which was followed by over forty designs of Home Savings and Loan Buildings throughout California over the next twenty years. In those designs he incorporated sculpture and mural work. During the course of his career he created over one hundred such murals for buildings throughout the United States. The University of Notre Dame awarded him an honorary Doctor of Laws after he completed a mural design for their library.

Throughout the 1970s and 1980s, Sheets continued to be an indefatigable artist. Always believing in the value of arts education and in teaching as his most important role, he continued those efforts with his many painting workshops held all over the world between 1965 and 1985. He also served as an American Art Specialist for the United States Department of State in Turkey and Russia in 1960 and 1961.

Sheets held memberships in the California Water Color Society, the American Watercolor Society, the Art Directors Guild, the Bohemian Club, Century Association, the National Academy of Design, and the National Watercolor Society. His numerous awards included first prize, California State Fair, 1932, 1933; the Watson F. Blair Purchase Prize, International Water Color Exhibition, Art Institute of Chicago, 1938; the Philadelphia Water Color Club Prize, Pennsylvania Academy of the Fine Arts, 1939; the Dana Water Color Medal, Pennsylvania Academy of the Fine Arts, 1943; the Gold Brush Award, Artists Guild of Chicago, 1951; and the Dolphin Award, American Watercolor Society, 1987.

Smith, Jack Wilkinson

Born February 7, 1873 in Paterson, New Jersey

Died January 8, 1949 in Monterey Park, California

Established residence in Southern California, 1906

Jack Wilkinson Smith began his art career while still in this teens, working as a "paint boy" in a Chicago scenic painting shop under artist Gardner Symons. He also studied at the Art Institute of Chicago and was influenced by the work of William Wendt. He later obtained employment as a sketch artist with the *Cincinnati Enquirer*. He received national recognition for his front-line sketches of battle scenes of the Spanish-American War. In Cincinnati he studied with Frank Duveneck (1848–1919) at the Cincinnati Art Academy.

In 1906 Smith visited Los Angeles, then traveled north to Oregon. Returning to Southern California he established a studio-home in Alhambra, in an area known as "Artists' Alley." His neighbors there included sculptor Eli Harvey (1860–1957) and painter Frank Tenney Johnson (1874–1939).

In 1923 he helped found the Biltmore Salon, a gallery devoted to Western artists. It featured the work of Smith, Johnson, Clyde Forsythe (1885–1962), George Brandriff, Carl Oscar Borg, Hanson Puthuff, and William Wendt, among others.

Smith was best known for his seascapes and mountain landscapes. He was a member of the California Art Club, the Sketch Club, and the Laguna Beach Art Association. His awards included a silver medal, Panama-California Exposition, San Diego, 1915; a gold medal, California State Fair, 1919; and gold medals, Painters of the West, 1924 and 1929.

Stuber, Dedrick Brandes

Born May 4, 1878 in New York City

Died August 18, 1954 in West Hollywood, California

Established residence in Southern California, 1920

Dedrick Stuber studied at the Art Students League in New York and received criticism from the American Barbizon painter Henry Ward Ranger (1858–1916). He also admired the French Barbizon artists Camille Corot and Charles François Daubigny.

In New York he painted in the countryside of Westchester County and on Long Island. He exhibited his paintings at the National Academy of Design in 1911 and 1912. He moved to California in 1920, settling in Los Angeles where he became an active member of the art community.

Primarily known for pastoral subjects, Stuber painted from San Diego to Monterey. A favorite locale was at Lake Elsinore. He also painted cityscapes, seascapes, harbor scenes, and night scenes. He was known to paint from late evening until early morning in order to capture particular light effects.

Stuber was a member of the Painters and Sculptors of Southern California, the Laguna Beach Art Association, and the Glendale Art Association.

Symons, George Gardner (né Simon)

Born October 19, 1862 in Chicago, Illinois

Died January 12, 1930 in Hillside, New Jersey

First to California, early 1880s; established residence in Southern California (seasonal), 1903

Gardner Symons received his art education at the Art Institute of Chicago and in Paris, London, and Munich. He worked as a commercial artist in Chicago where he was active in the local art circles. He became a close friend and painting companion to William Wendt.

Symons first came to California in the early 1880s, painting in an area from Los Angeles to Santa Barbara. He returned again in 1896, accompanied by Wendt. In 1898 the two artists traveled to England where they painted at St. Ives, Cornwall.

In California Symons had been charmed by the seaside village of Laguna Beach, and around 1903 he built a studio there which he would use periodically throughout his career. He maintained other studios in the East—in Brooklyn, New York City, and in the Berkshires of Massachusetts. He also continued to go to St. Ives. At St. Ives he met artist Walter Elmer Schofield (1867–1944) whom he persuaded to come to Los Angeles in 1928 and 1929. Joint exhibitions of their works were held at Stendahl Galleries. Symons was a member of many arts organizations on both the East and West Coasts including the California Art Club, the National Arts Club, the Chicago Society of Artists, the Salmagundi Club, and the Laguna Beach Art Association. He was also a member of the Institute of Arts and Letters and the Royal Society of British Artists. Elected an associate at the National Academy of Design in 1910, he became a full academician the following year.

The recipient of many awards—reportedly by 1911 more than any other Eastern American artist—Symons received the Carnegie Prize, National Academy of Design, 1909; the Evans Prize, Salmagundi Club, 1910; a gold medal, National Arts Club, 1912; and the Saltus Gold Medal, National Academy of Design, 1913, to name only a few.

Symons' given name was Simon which he apparently changed due to concerns over anti-Semitism when he returned to Brooklyn from England in 1908. Works prior to that year are signed "Simon."

Wachtel, Elmer

Born January 21, 1864 in Baltimore, Maryland

Died August 31, 1929 in Guadalajara, Mexico

Established residence in Southern California 1882

In 1882 Elmer Wachtel came to Southern California to live with his older brother, John, who was married to the sister of Guy Rose and managing the Rose family ranch, Sunny Slope. An aspiring violinist, Wachtel became first violin of the Philharmonic Orchestra in Los Angeles in 1888. He also held the same position from 1893 to 1894 with A. J. Stamm's Philharmonic Orchestra.

During this time he also pursued an interest in drawing and painting. He became involved in local art circles which included Gutzon Borglum (1871–1941) and J. Bond Francisco (1863–1931). With several other artists they founded the Los Angeles Art Association in the late 1880s.

Some time in 1895 Wachtel went to New York and enrolled in the Art Students League, but, unhappy with the teaching methods, left after only two weeks. He remained in New York and received criticism from William Merritt Chase (1849–1916). Working in watercolor, he exhibited with the New York Water Color Society. After returning to California in 1896, he spent a brief period in San Francisco where he exhibited with the San Francisco Art Association. He then returned permanently to Los Angeles.

Wachtel worked as a pen-and-ink illustrator for *Land of Sunshine* and *Californian* magazines. Around 1900 he went to England and Europe, studying at the Lambeth Art School in London and visiting and painting with his friend Gutzon Borglum who was living there. He also associated with the English illustrators Fred and Tom Wilkinson.

Wachtel returned to Los Angeles and, within a few years, established a reputation as an accomplished land-

scape artist. William Keith sent the young artist Marion Kavanaugh to see him in 1903, and they were married in Chicago the following year.

Elmer Wachtel and Marion Kavanagh Wachtel (she began to omit the "u" from her maiden name) spent the next twenty-five years as inseparable painting companions, he working in oils and she in watercolor. They traveled throughout California, the deserts of Arizona and New Mexico, and in Mexico. It was during a painting trip to Guadalajara in 1929 that Wachtel died.

Wachtel was an individualist who shunned the many arts organizations that developed in the early 1900s. He refused to join the California Art Club at its founding in 1905. This in no way affected the esteem in which he was held by his fellow artists. One-man exhibitions were held for him at the Museum of History, Science, and Art in 1915 and 1918. A memorial exhibition was held at Kanst Art Gallery in 1930. He received two awards from the San Francisco Art Association: for watercolor, in 1902; and for oils, in 1906.

Wachtel, Marion Kavanagh (nee Kavanaugh)

Born June 10, 1876 in Milwaukee, Wisconsin

Died May 22, 1954 in Pasadena, California

First to California, 1903; established residence in Southern California, 1904

Marion Kavanaugh studied at the Art Institute of Chicago and in New York with William Merritt Chase (1849–1916). For several years she taught at the Art Institute of Chicago. She then traveled to San Francisco to study with William Keith (1838–1911). Keith recommended that she go to Los Angeles to see artist Elmer Wachtel. They met in 1903 and were married the following year in Chicago. Thereafter she signed her name as "Marion Kavanagh Wachtel."

Returning to Los Angeles, the couple built a studio-home in the Mt. Washington area. They remained there until 1921 when they moved to the Arroyo Seco area of Pasadena. As inseparable painting companions, they traveled throughout Southern California and the desert Southwest. Originally trained as a portrait artist, Wachtel painted portraits of the Hopi on a trip to Northern Arizona and New Mexico in 1908.

Perhaps so as not to compete with her husband, Wachtel worked primarily in watercolor throughout their marriage and displayed remarkable dexterity in the handling of the medium, which could be quite unforgiving, even to the most skilled. She received high praise for her works, which are delicate, lyrical interpretations of the landscape. She was elected to the New York Water Color Club in 1911, was elected an associate of the American Water Color Society in 1912, and was a founding member of the California Water Color Society in 1921. She also held memberships in the Pasadena Society of Artists and the Academy of Western Painters. Her works were exhibited jointly with her husband as well as in solo exhibitions in Los Angeles. One-person exhibitions of her paintings were held at the Los Angeles Museum of History, Science, and Art in 1915 and 1917.

After her husband's death in 1929, Wachtel temporarily lost interest in painting. She resumed working around 1931, painting the landscape around her home on the Arroyo Seco.

Wendt, William

Born February 20, 1865 in Bentzen, Germany

Died December 29, 1946 in Laguna Beach, California

To the United States, 1880; first to California, 1896; established residence in Southern California, 1906

William Wendt immigrated to the United States in 1880, settling in Chicago where he worked in a commercial art firm. Essentially self-taught, for a brief period he attended evening classes at the Art Institute of Chicago. He preferred painting the landscape and became an active exhibitor in Chicago, winning the Second Yerkes Prize at the Chicago Society of Artists exhibition in 1893.

Wendt became friends with artist Gardner Symons, and they made a number of trips together to California between 1896 and 1904 and, in 1898, to the art colony at St. Ives in Cornwall. Works from those trips were exhibited at the Art Institute of Chicago.

Wendt settled in Los Angeles with his wife, sculptor Julia Bracken, in 1906. Already a successful painter, he quickly became a leading member in the art community and was a founding member of the California Art Club in 1909. He moved his home and studio to the art colony at Laguna Beach in 1912, the same year that he was elected to the National Academy of Design. He was a founding member of the Laguna Beach Art Association in 1918 and, although somewhat shy and reclusive, he was the art colony's most important resident artist-teacher.

Wendt perceived nature as a manifestation of God and viewed himself as nature's faithful interpreter. Only rarely did he include figures or animals in his landscapes. He worked out of doors, sometimes sketching, and sometimes making large, finished works. His early works reflect the feathery brushstrokes and hazy atmosphere of Impressionism. In his later works, after about 1912, he employed a distinctive block or hatch-like brushwork giving solidity to natural forms. A prolific painter, he became known as the "dean" of Southern California's landscape painters.

Exhibiting regularly in exhibitions in Los Angeles, Chicago, and New York, Wendt received numerous awards for his works. Among these were a bronze medal, Pan-American Exposition, Buffalo, 1901; a silver medal, Louisiana Purchase Exposition, St. Louis, 1904; and a silver medal, Panama-Pacific International Exposition, San Francisco, 1915. In 1925 he received a gold medal at the Pan-American Exhibition in Los Angeles for *Where Nature's God Hath Wrought*, which is now in the collection of the Los Angeles County Museum of Art.

Williams, Virgil Macey

Born October 29, 1830 in Dixfield, Maine

Died December 18, 1886 in St. Helena, California

First to California, 1862; established residence in Northern California, 1871

Virgil Williams studied art at Brown

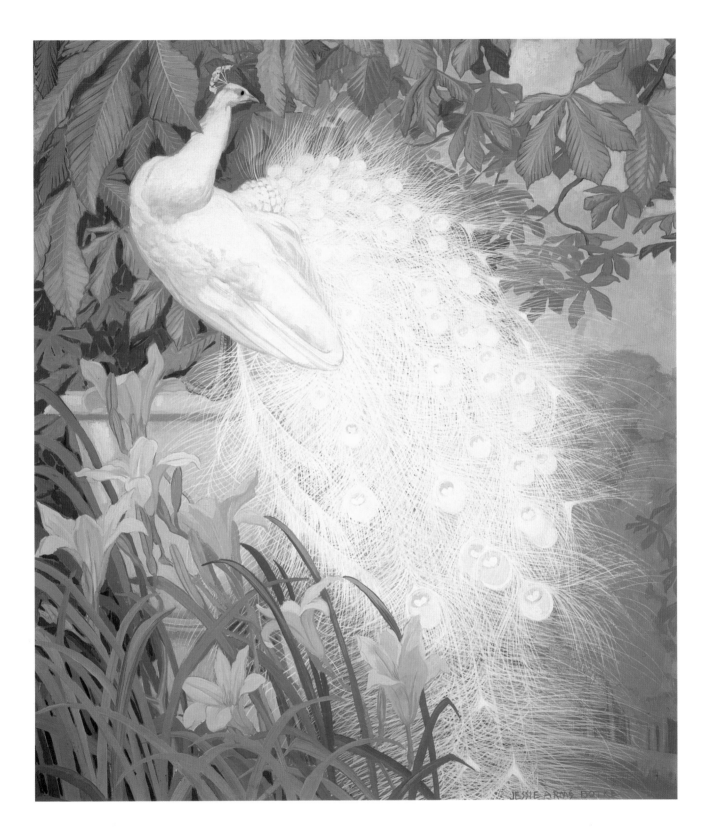

JESSIE ARMS BOTKE
White Peacock and Day Lilies, c. 1930
Oil on board
24 x 20 inches

Although Jessie Arms Botke exhibited with many of the Impressionist artists, her style was not Impressionist by any definition. Her works are characterized by a rich surface, saturated with color and line resulting in a strikingly decorative effect.

University and with Daniel Huntington (1816–1906) in New York. He continued his instruction in Paris and in Rome from 1853 to 1860 under the American artist William Page (1811–1885). In 1860 he settled in Boston where he taught art at Harvard University and at the Boston School of Technology.

In 1862 he visited San Francisco to execute a commission. In 1871 he moved there, where in 1874 he became director of the newly formed San Francisco School of Design, a post he held until his death. A well-loved artist and teacher, he influenced a large number of artists during his career.

Williams' style is decidedly academic, exhibiting forceful draftsmanship and a high degree of technical virtuosity. Most of his works relate to his European sojourn, and very few represent California subjects.

Williams was a member of the San Francisco Art Association and the Bohemian Club.

Yens, Karl Julius Heinrich

Born January 11, 1868 in Altona, Germany

Died April 13, 1945 in Laguna Beach, California

To the United States, 1901; established residence in Southern California, 1910

Karl Yens studied in Berlin with Max Koch, then in Paris with Benjamin Constant (1845–1902) and Jean Paul Laurens (1838–1921). He worked as a muralist in Germany, then in Scotland. In 1901 he immigrated to the United States where he did murals in New York and Washington, D.C.

In 1910 Yens moved to Southern California. He became active in the art circles in Los Angeles and Pasadena. In 1918 he moved to Laguna Beach where he built a studio-home on Coast Highway near Ruby Street. He was a founding member of the Laguna Beach Art Association in the summer of 1918.

Yens worked in both oil and watercolor, painting a variety of subjects including portraits, figure works, still lifes, landscapes, and genre scenes. His style is colorful and decorative.

Yens held memberships in a number of arts organizations including the California Art Club, the Academy of Western Painters, the California Water Color Society, the Painters and Sculptors of Los Angeles, and the San Diego Fine Arts Society. He received many awards for his work.

Selected Bibliography

Anderson, Susan M. *Regionalism: The California View, Watercolors, 1929-1945*, exhibition catalogue. Santa Barbara: Santa Barbara Museum of Art, 1988.

Anderson, Thomas R., and Bruce A. Kamerling. *Sunlight and Shadow: The Art of Alfred R. Mitchell, 1888-1972*, exhibition catalogue. San Diego: San Diego Historical Society, 1988.

Art of California. San Francisco: R. L. Bernier Publisher, 1916.

Baigell, Matthew. *The American Scene: American Painting of the 1930s.* New York: Praeger Publishers, 1974.

Baird, Joseph Armstrong, Jr., ed. *From Exposition to Exposition: Progressive and Conservative Northern California Painting, 1915-1939*, exhibition catalogue. Sacramento: Crocker Art Museum, 1981.

Brinton, Christian. *Impressions of the Art at the Panama-Pacific Exposition.* New York: John Lane Co., 1916.

Brother Cornelius, F.S.C. *Keith: Old Master of California.* New York: G. P. Putnam's Sons, 1942.

Cahill, Holger. *American Art Today, New York World's Fair.* New York: National Art Society, 1939.

California Design 1910. Pasadena: California Design Publications, 1974.

California Grandeur and Genre: From the Collection of James L. Coran and Walter A. Nelson-Rees, exhibition catalogue. Palm Springs, California: Palm Springs Desert Museum, 1991.

Carl Oscar Borg: A Niche in Time, exhibition catalogue. Palm Springs: Palm Springs Desert Museum, 1990.

Coen, Rena Neumann. *The Paynes, Edgar and Elsie: American Artists.* Minneapolis: Payne Studios Inc., 1988.

Color and Impressions: The Early Work of E. Charlton Fortune, exhibition catalogue. Monterey, California: Monterey Peninsula Museum of Art, 1990.

Dominik, Janet Blake. *Early Artists in Laguna Beach: The Impressionists*, exhibition catalogue. Laguna Beach, California: Laguna Art Museum, 1986.

Falk, Peter Hastings. *Who Was Who in American Art.* Madison, Connecticut: Sound View Press, 1985.

Gerdts, William H. *American Impressionism.* New York: Abbeville Press, Publishers, 1984.

_____. *American Impressionism*, exhibition catalogue. Seattle: The Henry Art Gallery, 1980.

Granville Redmond, exhibition catalogue. Oakland: The Oakland Museum, 1988.

Hailey, Gene, ed. *Abstract from California Art Research: Monographs.* W.P.A. Project 2874, O.P. 65-3-3632. 20 vols. San Francisco: Works Progress Administration, 1937.

Hatfield, Dalzell. *Millard Sheets.* Los Angeles and New York: Dalzell Hatfield, 1935.

Hughes, Edan Milton. *Artists in California: 1786-1940.* 2d ed. San Francisco: Hughes Publishing, 1989.

Impressionism: The California View, exhibition catalogue. Oakland: The Oakland Museum, 1981.

Laird, Helen. *Carl Oscar Borg and the Magic Region.* Layton, Utah: Gibbs M. Smith, Inc., Peregrine Smith Books, 1986.

Lovoos, Janice, and Edmund F. Penney. *Millard Sheets: One-Man Renaissance.* Flagstaff, Arizona: Northland Press, 1984.

Lovoos, Janice, and Gordon T. McClelland. *Phil Dike.* Beverly Hills, California: Hillcrest Press, Inc., 1988.

McClelland, Gordon T., and Jay T. Last. *The California Style: California Watercolor Artists, 1929-1955.* Beverly Hills: Hillcrest Press, Inc., 1985.

Millier, Arthur. "Growth of Art in California." In *Land of Homes* by Frank J. Taylor. Los Angeles: Powell Publishing Company, 1929.

Moure, Nancy Dustin Wall. *Artists' Clubs and Exhibitions in Los Angeles before 1930.* Los Angeles: Privately Printed, 1974.

_____. *The California Water Color Society: Prize Winners, 1931-1954; Index to Exhibitions, 1921-1954.* Los Angeles: Privately Printed, 1973.

_____. *Dictionary of Art and Artists in Southern California before 1930.* Los Angeles: Privately Printed, 1975.

_____. *Painting and Sculpture in Los Angeles: 1900-1945,* exhibition catalogue. Los Angeles: Los Angeles County Museum of Art, 1980.

_____. *William Wendt, 1865-1946,* exhibition catalogue. Laguna Beach, California: Laguna Beach Museum of Art, 1977.

Nelson-Rees, Walter A. *Albert Thomas DeRome, 1885-1959.* Oakland: WIM, 1988.

Nochlin, Linda. *Realism.* New York: Penguin Books, 1971.

Orr-Cahall, Christina. *The Art of California: Selected Works of The Oakland Museum.* Oakland: The Oakland Museum Art Department, 1984.

Perine, Robert. *Chouinard: An Art Vision Betrayed.* Encinitas, California: Artra Publishing, Inc., 1985.

Petersen, Martin E. *Second Nature: Four Early San Diego Landscape Painters,* exhibition catalogue. San Diego: San Diego Museum of Art and Prestel-Verlag, Munich, 1991.

Southern California Artists: 1890-1940, exhibition catalogue. Introduction by Carl Dentzel. Laguna Beach, California: The Laguna Beach Museum of Art, 1979.

Stern, Jean. *Alson S. Clark.* Los Angeles: Petersen Publishing Co., 1983.

_____. *Masterworks of California Impressionism: The FFCA, Morton H. Fleischer Collection.* Phoenix: FFCA Publishing Company, 1986.

_____. *The Paintings of Franz A. Bischoff.* Los Angeles: Petersen Publishing Co., 1980.

_____. *The Paintings of Sam Hyde Harris.* Los Angeles: Petersen Publishing Co., 1980.

Tonalism: An American Experience. New York: Grand Central Art Galleries Art Education Association, 1982.

Trenton, Patricia, and William H. Gerdts. *California Light 1900-1930,* exhibition catalogue. Laguna Beach, California: Laguna Art Museum, 1990.

Vincent, Stephen, ed. *O California!: Nineteenth and Early Twentieth Century California Landscapes and Observations.* San Francisco: Bedford Arts, Publishers, 1990.

Westphal, Ruth Lilly. *Plein Air Painters of California: The North.* Irvine, California: Westphal Publishing, 1986.

_____. *Plein Air Painters of California: The Southland.* Irvine, California: Westphal Publishing, 1982.

Westphal, Ruth Lilly, and Janet Blake Dominik, eds. *American Scene Painting: California, 1930s and 1940s.* Irvine, California: Westphal Publishing, 1991.

Index to Artists and Paintings